STREETS 01

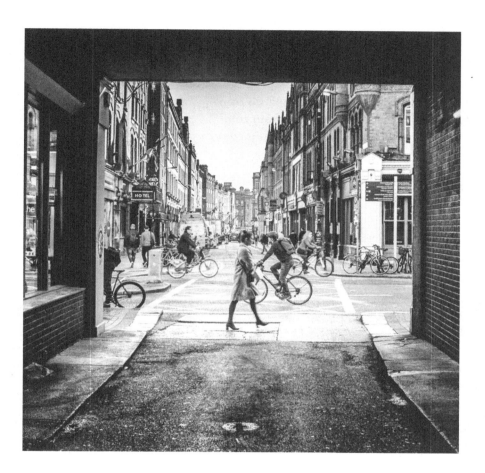

Explorations in street photography around Dublin, Ireland

Streets of Dublin

By Joe Houghton

First published in Ireland in 2019
First edition – September 2019

Website :	**www.houghtonphoto.com**
Email :	**joe@houghtonphoto.com**
LinkedIn :	**https://www.linkedin.com/in/joehoughton/**

ISBN : 978-1-9162380-1-5

Acknowledgements :

Penny of course, for all her love and support, and for designing the book cover. Shay Hunston for the photo of me. Jacques Sellschop, and Feargal Quinn for casting a critical eye and offering useful critique. And to all the subjects of the images – thank you!

Dedication

For Penny – love you!

Table of Contents

1. Welcome to the Streets of Dublin

This little book is me sharing my thoughts and learnings about street photography as I continue my journey into this fascinating and absorbing area of the craft of drawing with light. I'm about a year into exploring the streets of Dublin as a street photographer, capturing some of the myriad and ever-changing sights which continually present themselves and, along the way, I've picked up a few things that might help others as they consider shooting this style. So welcome to my world, and I hope that some of my musings prove interesting or useful to you.

Photo by Shay Hunston

This way...

This way is a familiar staple in any street photographer's arsenal: the dark alleyway ending in light. What made this one stand out for me was the lovely arrow pointing back at me, so I got down low – much to the bemusement of a lorry driver who turned into the alley – and then waited for a passerby to add the movement, watched over by the two mannequins in the shop window across the street. The yellow lines either side of the road take the eye in through the shot. Or is it out? The arrow turns the normal flow of the viewer's attention around in this image, which adds to the interest and dynamic.

These are simply my thoughts and observations. I'm barely scratching the surface, but the joy I'm experiencing from taking, making and sharing street images has rekindled my love of photography in a way that I've not felt for a long time.

We are all on a journey as we develop our skills and inner vision of how to create images that matter to us and to others – I'd like to share a few steps of my own with you.

This is an on-going project, so please check the website (more on that below) for all the images and news about the project as it develops…

Paraphrasing the words of the wonderful song by Ralph McTell…

Let me take you by the hand,

And lead you through the streets of Dublin…

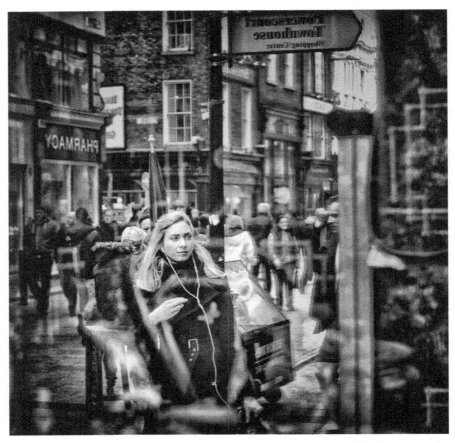

Window shopping

Window shopping is one of my first street photos, taken on a busy Saturday afternoon in a bustling street full of people out in town. I took up a position a few feet from this large shop window and waited for something to happen. The lady with the headphones jumps out of the frame she's so clear, even reflected in the glass. It's this "lucky" happenstance that makes street photography so rewarding.

2. Just do it!

Why write a book like this? I listen to a number of podcasts about self-improvement and development, and recurring theme in so many of these is "Just do it!" Especially with photography, it's so easy to make hundreds or thousands of images, and have them sit on your hard drive, with a few perhaps making their way out onto social media, ephemeral blips picking up likes for a day or two then disappearing down the feed, never to be seen again.

Looking at those authors and photography luminaries who have informed and continue to inform my own development, it's easy to tell myself, it's all been done, and far better than I could ever do it. So I've never let myself get past that wall, and try to create something a little more permanent, a footprint in the sands of time that might be seen in future by others seeking to master this wonderful craft. So, here's me "just doing it!" I hope that some of my work gives you something to think on, learn from, or try in your own explorations.

If you are out there shooting, things will happen

for you. If you're not out there, you'll only hear

about it. – Jay Maisel

3. The Streets of Dublin website

The website for this project can be found at

https://www.houghtonphoto.com/streets-of-dublin

Images from the project are grouped into a number of galleries, which will be added to as the project continues to develop.

Other activity emanating from the project will also be recorded here, so please do check it out. I'm working with some schools on a collaborative project where the images are used as the inspiration for creative writing pieces by students, and there has been some media interest as well - all will be kept updated on the website.

Image technical data

I know that some photographers will want to know the camera settings for images they see, so technical information on each photo such as shutter speed, exposure, camera model, lens and ISO can be found in a section at the end of the book, ordered by image title. Where the aperture shows as $f/1$, I was using a manual lens (probably the little Meike 25mm or Olympus 85mm mentioned later) on an adapter which didn't let the camera record the aperture information.

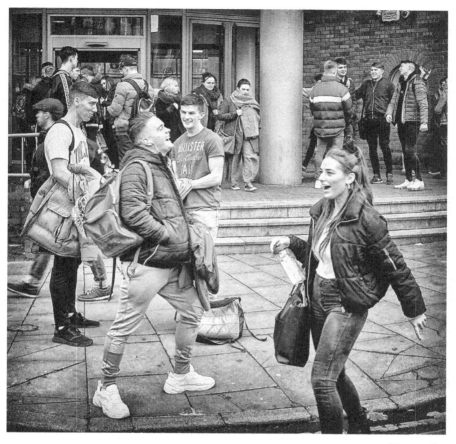

Happy days

Happy days was taken looking at the steps of Dublin Institute of Technology on Aungier Street as I arrived for a meeting there. The life and energy of the students was so arresting that I stopped across the street and pulled out the camera. This is street photography doing what it should: capturing the interactions and life of the young people congregated there, and prompting the viewer to ask what they found so funny, or what had just happened to elicit the reactions we see in frame.

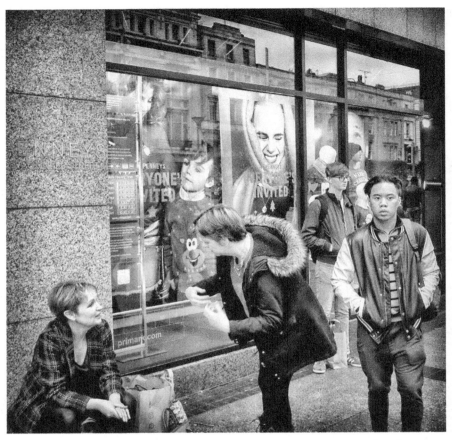

Catching up…

Catching up… caught my eye on O'Connell Street one afternoon as I wandered up towards The Spire. Initially it was Penneys shop window with the faces that offered potential for something to happen, and then as I walked up, the scene as captured happened as the lady on the left squatted down for a brief respite and her friend chatted to her. I love the way the little lad's face on the window poster behind seems to look at the two of them, and the man to the right of frame is looking off camera to something behind me, which adds another layer to the narrative.

4. A fork in the road…

"Two roads diverged in a wood, and I —

I took the one less travelled"

Robert Frost

I've been a photography trainer for many years, working primarily with Nikon DSLRs, and had reached something of a plateau in my photography journey – not an uncommon occurrence for anyone, but still, once recognized, this became something of a mental block for me. I was capable of taking a technically good shot in most situations, but apart from the photos of my family, these "perfect" images often didn't speak to me, didn't really evoke any deep feelings or reactions from me as I revisited them. Sure, they looked great on screen, but I didn't care about them in any meaningful way.

But as so often happens in life, something crops up which offers a new way of seeing, of framing the world, or of approaching it. I was becoming increasingly aware of the sheer weight and bulk of my DSLR gear – taking Nikon D810, pro lenses, typically a tripod and perhaps filters and a bag with me as I went off for a shoot. I would come home aching and sore, even though I had invested in decent straps to distribute the load better.

We have had the chance to do a number of family trips to South Africa in recent years, but with a wife and two little ones, packing camera gear became something I was starting to see as almost a task to dread. I struggled to choose which lenses to take and which to leave behind, and how many of the myriad gadgets and gizmos my gear acquisition syndrome fills our shelves with simply had to find space in my hugely overburdened rucksack. Now don't get me wrong, I love my Nikon gear. I love the weight and heft of the D810, the reassuringly solid and precise operation of the lenses, and the solidity of my big heavy Manfrotto tripod legs. I love the way shooting with a tripod, filters and a wide angle lens makes me slow down and think as I compose a landscape shot, or seek to capture a nightscape. I really do enjoy the challenge of wielding my 600mm to track a bird in flight and still get a sharp, well-composed shot.

Maybe it's because I'm getting older and creakier, that my joints and muscles aren't as flexible and pliable as they used to be, or maybe I'm just unfit and should work out more! But for day-to-day shooting, I was finding the weight and size of my gear was putting me off taking the camera at times. This crystallized for me when I took a short-term contract to work with a company in central Dublin for a couple of days a week, forcing me into the "auld town" where I rarely ventured unless I had to.

Another part of the confluence of factors which were – unbeknownst to me – converging to my impending photographic "fork in the road" was a suggestion from my wife Penny. I'd been looking at parking options in Dublin, and it was clear that cars are not welcome in the city centre any more! Most of the major car parks were very expensive to park in for a full working day, not to mention the time it would take to commute in the seven miles from my house along one of the busiest arterial roads leading into the city. Losing the guts of two or three hours commuting and €30 or €40 each day was making my day in Dublin look much less appealing.

Then Penny suggested: "Why not take the bus?" Amazing how seemingly inconsequential conversations can lead to unexpected consequences, but these five words opened up a new set of opportunities and experiences for me.

All photographs are memento mori. To take a photograph is to participate in another person's (or thing's) mortality, vulnerability, mutability. Precisely by slicing out this moment and freezing it, all photographs testify to time's relentless melt.

Susan Sontag

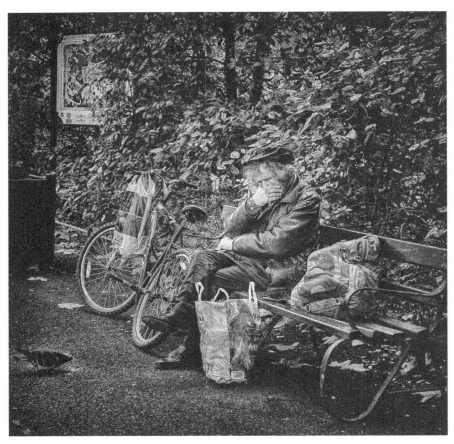

Quiet spot for a nap...

Quiet spot for a nap... *This chap was taking a few minutes of downtime in Stephen's Green, the wonderful space in the heart of Dublin beloved by so many of the city's inhabitants. I liked the way he almost blends into the foliage, becoming a natural part of the scene, the pigeon in the foreground quite unconcerned at its close proximity.*

Riverdance

Riverdance was a shot taken as I was seated outside Eva & Bibi's coffee shop on O'Connell Street, watching the world go by. I noticed that every now and then the passers-by would almost line up, so I pre-focussed on the street light pole, and waited… A good example of how awareness of both your surroundings but also the ebb and flow of the space you are in can lead to a shot.

As I loaded up my messenger bag that first morning, it occurred to me that I would be spending time in the city where I rarely ventured, and that I should take my camera and get some shots. But even armed with the "nifty 50", my D810 was simply too big and bulky to fit in alongside my computer, charger and other bits and pieces. So I left it at home and headed off to the bus stop feeling frustrated that I was going out without a "proper" camera.

Now I can hear some of you saying "What's the problem— surely you have your phone?" And yes, I have an iPhone 6+, which takes perfectly adequate shots. But it's not a camera, it's a phone. Call me old-fashioned, but there's something different – at least for me– in the experience of taking a photograph with a phone versus using a "proper" camera. By "proper" I mean a dedicated device for making photographs, with a viewfinder, which fits into my hand and has easily accessible controls for shutter speed, aperture and ISO. I know there's huge opportunity to capture amazing images with my phone, and that composition should be unaffected so long as you have a frame to place a scene inside. There are some incredible photographers out there – iPhoneographers I think they are called – who have produced fabulous work using these devices, but for me, there's more to making a photo than just having a screen on which to record an image.

Which brings me on to the gear I use for street photography, and why it is such an integral part of this story and my love of this medium...

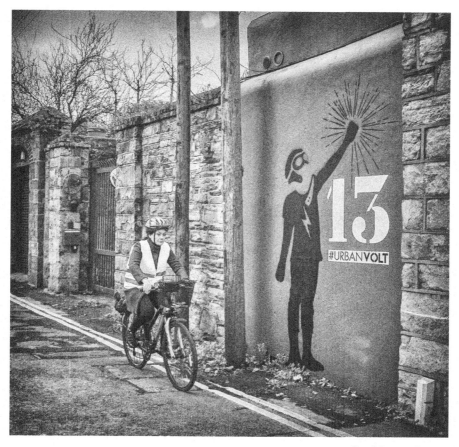

Lad Lane, Dublin

Lad Lane *was shot on my way to a client meeting – always have your camera out. I make it a habit of always having my camera around my neck when walking to/from work engagements, because you simply never know when an opportunity for an image will appear. Street art naturally draws the eye and it was the yellow of the cyclist's jacket that engaged my brain as I mentally visualised the mono shot with the white of the 13 and saw that these would work together. Pre-visualization of the scene you see in colour as a black and white image is a skill that has to be learned and practiced, and this image is an example of this for me.*

5. Gear

"The camera is an instrument that teaches people how to see without a camera. – Dorothea Lange"

That bus journey crystallised in my head that I needed some new gear to address the problem I was facing. Although I hold my hands up to being a long-time sufferer of gear acquisition syndrome (GAS), this was not really in that space – although Penny might not agree! Here was a specific problem I was facing with the current gear I had being a constraint: the Nikon was simply too big and heavy to let me carry it into town comfortably when I was going to work.

So I began to look around at options. In recent years mirrorless cameras have become increasingly popular, so I was interested to see if they might offer me anything, being smaller and lighter than the classic DSLR format.

Many of the top end models are still fairly bulky, especially with a medium zoom lens attached, so my search began to hone in on small bodies, with pancake or quite flat lenses – the physical form factor being important to fit into the messenger bag along with a Mac and charger.

There's a great podcast (and website) by long-time pro Derrick Storey called *The Nimble Photographer*, which I've listened to for a few years now He espouses the benefits of small, light kit – something I was coming to really see as coinciding with my own needs. He talks about the Olympus Pen models, so I had a good look at them, and liked what I saw – small, light, great optics – but the physical cameras were too small to fit comfortably into my quite large hands.

Most photographers know the Leica brand – after all, the master Henri Cartier-Bresson shot Leica, and it's undoubtedly one of the best-known and premium brands hankered after by most photographers, but I've always thought that a Leica was out of my price range – and it still is! Then I came across an article that talked about the Fuji X series cameras, and how they acted and handled like the Leicas of old, so I started investigating Fuji.

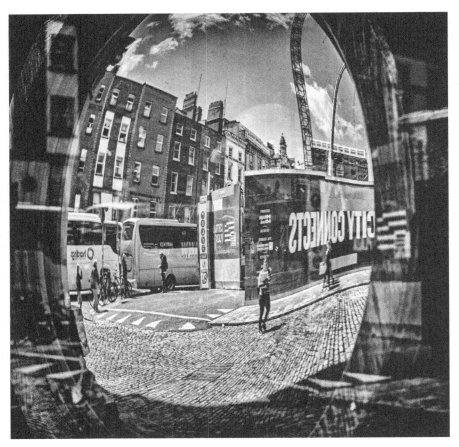

Distortion

Distortion *is an image reflected in a convex mirror on Dame Street. I liked the effect of bent verticals and the contrast of the bright circle of light that caught my eye as I approached the building. I tend to be quite fixated on keeping verticals aligned, so this is a conscious breaking of the rules – a good thing to do now and then.*

This was another key moment in my realization of what I was looking for, coming into clearer focus the more time I invested in the process of reading, listening and generally immersing myself in the possibilities of smaller, lighter camera systems than the Nikon DSLR world I had really existed in – to the exclusion of everything else – for the past 10 years. When I saw the Fuji cameras, I realised that the physical form of the camera body itself was going to be a key part of this move of mine into a nimble, more portable camera experience.

And that's a key word here: experience.

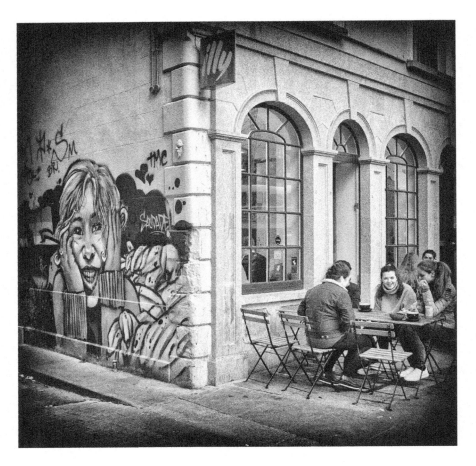

Smile

Smile had me reaching for the camera for a number of reasons. Obviously, the mural was arresting, especially since it is in vibrant colours but with good contrast for successful mono conversion. I also liked the corner of the building separating the image down a thirds line, and then I waited for a second or two and, as if she read my mind, the smiling lady made eye contact. Seeing the possibilities in a shot as you approach a spot is a skill you develop and continue to hone as a street photographer: an always fascinating challenge that sometimes works but often doesn't.

5.1. Fuji X100s

The Fuji rangefinder-type bodies instantly appealed to me, and the retro metal dials, aperture ring on the front lens – all this instantly resonated. Silent shooting; the leaf shutter giving me options not available with a conventional DSLR; X-Trans sensor... the list of features that offered me new opportunities for shooting went on and on. But the key here was the look and feel of the – simply beautiful – styling and aesthetically formed body and controls.

You might be wondering about the fixed prime lens on some X series models. The Fuji X100s, which began as my constant travelling companion, has a 23mm fixed lens that gives a 35mm equivalent field of view on the crop sensor. No zoom, no option to swap lenses, just you, the view you get, and your feet to move around to alter your composition. Robert Capa, the great Magnum photographer said: "If your pictures aren't good enough, you aren't close enough." Well, he knew what he was doing, and in 1936 captured another of the great decisive moment shots of all time, *The Falling Soldier*, showing the instant a man is caught by gunfire in the Spanish Civil War.

So I embraced the challenge of learning to live with fewer kit options and embarked on a learning curve of mastering one camera without all the distractions of changing lenses and focal lengths.

And then I began to read user reviews of the X100 and its successors. Almost all of them talk in terms of how this camera changed their approach to shooting and how close to perfection this beautiful little camera comes to being the ideal street photography companion. There's a great video up on YouTube by Zack Arias as he takes us around Istanbul. Watch it and you'll see what I mean.

After that, it was as much a budgetary decision as anything else. I am evolved enough to know that I don't need the latest greatest camera model to get good photos. So I focussed in on the second-generation model, the X100s, which offer the Fuji physical camera body experience with some significant improvements over the first generation model. A week or two scanning the local second-hand camera forums, and I found one within my price range and picked it up one wet and windy evening after a training session I'd delivered in town.

That was a year ago, and since then I've shot this little beauty most weeks at some point. Yes, I've read about the X100T and F, but really, I don't need higher megapixels, and the other technical improvements are not must-haves for the type of images I'm trying to create. I was happy with my six-year-old, perfectly formed little street companion. No, more than happy: I actively look forward to going out and shooting, even taking early buses to get some time in before the working day to capture a few shots while the light is good – but more on that later…

5.2. Articulating screen – the X-T2

After shooting with the X100s for a few months, one aspect of using it for street work began to cause me to think about other options. I was finding that having to shoot with the camera up to my eye, or if not then with the rear screen high enough to be visible when shooting in live-view, often resulted in my subjects becoming aware of the fact that I was taking the shot. My wife Penny has an X-A3, and the articulating screen proved to be a real boon out shooting street when I borrowed it on a couple of outings.

So the hunt was on for another Fuji camera with all the manual controls I love on the X100s but also a flip screen. This led me to the X-T2, a gem of a camera that has supplanted my X100s since I bought it.

Moving to the X-T2 brought a new problem: lens choice. The X100 series is a fixed 23mm lens, which is one of its strengths, but the X-T2 arrived as a body only. Even secondhand it was a significant purchase. So I needed to buy a lens, as I figured that pinching Pennys from her X-A3 probably wasn't a long-term runner.

Now Fuji has a great line-up of primes, but they are relatively expensive. So I researched two options I'd never really explored with any camera system before: adapter rings and third-party lenses.

5.3. Adapter rings

I discovered that there are adapter rings that allow lenses from different systems to be used with bodies from other systems. A few euro bought me a K&F Concept adapter that fixes to the X-T2 and allows me to mount my Nikon full-frame lenses. This was a revelation, and so for a while I shot my Nikon 50mm f/1.8 with the adapter very happily on the X-T2. However, it was nowhere near as small a profile as my X100s, and didn't fit comfortably into the messenger bag – a key requirement for my street gear.

Option two is the fact that there are a number of cheaper third-party lens manufacturers with small prime lenses suitable for the X mount. Now these are almost all manual focus, but so are the Nikon lenses on the adapter. To be honest, I'm really enjoying the challenge and discipline of shooting and focussing manually, so I haven't seen this as a downside. Quite the opposite, as it's helping me to develop my camera craft further. So for the past couple of months I've been shooting a Meike 25mm f/1.8 on the X-T2, and getting some super shots with it – mostly street, but I also shot colour landscapes with it in Kerry and was very happy with the results. The majority of the images in this book are shot with this Meike lens.

Are the shots as sharp as with my Nikon 16-35 f/4? No, but that cost over €1,000. Whereas the Meike was €75, and the Nikon is four or five times as big and weighs over three times as much. And for my street shooting, I'm not pixel peeping anyway. I'm far more concerned with evoking emotion in the shots. And the X-T2/Meike 25mm combination is physically almost the same size and depth as the X100s, so it fits in my messenger bag – just!

There's a world of lovely old lenses from all different camera systems out there that I'd never even thought about. So an M42 adapter is on my wish list, which will open up an old Russian lenses to my Fuji. These will offer some distinctive "looks" and let me enjoy solid, well-crafted glass from years gone by with the latest in camera technology. I see Zenit coming back into my life after a 40-year absence, along with Takumar, Jupiter and others...

And as I finish up editing this book, I've just taken delivery of the lovely little pancake Fuji XF 27mm f/2.8 which is about half the depth of the Meike and really pares down my camera profile and weight to the minimum, give me Fuji glass and the option of autofocus. This lens is sharp, fast and so small - I'm getting some lovely shots using it!

So each time I reach an issue, I'm finding new options to explore and enjoy, both in my choice of kit and also in my technique. The constraint of light and small, portable camera/lens combination restricts choice, yes, but leads to focused decision making. This is proving fascinating, as it opens up possibilities and leads me into new areas I've never explored before.

5.4. Street settings

I'm finding that on many of my street excursions, I'm now shooting fully manual, setting ISO at around 320 to 400 to keep the shutter speed up, then focussing at infinity on the Meike 25mm, aperture around f/4 to f/8 and then adjusting shutter speed to the conditions. And slowly I'm getting more used to making these changes as I shoot, adjusting aperture and shutter speed on the run, switching focus if I get the chance to be up close.

5.5. Focus peaking

This is a magic bit of technology on many modern cameras. It highlights the areas of a shot within the plane of focus in the viewfinder, so you can see clearly what's in focus as you compose your shot. When shooting at large apertures, such as f/2.8 for instance, where there is a very narrow plane of focus, as you move the focus plane through the frame by twisting the focus ring on your lens, the narrow band of focus peaking highlights move through the frame like a rain-shower crossing a field. It's quite magical to see if you've never played with it.

The focus peaking on the Fuji cameras is just incredible as a visual aid, working either on the back screen or in the electronic viewfinder, showing white highlights for the zone of focus, which widens as the aperture opens up. That's something I'd never had on the DSLRs, and now miss when I go back to using them – a real advantage of the new mirrorless systems. If you've never had a play with using focus peaking as an aid to manual focussing, try it – it might just change the way you think about shooting. With the white peaking highlight set on the X-T2, especially when close enough for a head-and-shoulders portrait, the pupil of the eye is highlighted in white when it's in focus, making it very easy to grab focus precisely, even when using a manual lens. There's a quick little 1 minute video by Fujifilm showing this in action and the menus to set it up at https://bit.ly/2lLkp0s which is worth a look if this is new to you.

5.6. Slowing down

Yes, the new eye-tracking technology is amazing too on the newer autofocus lenses and bodies, but I'm kinda going the other way at present with my shooting: back to trying to master the camera and lens myself, rather than using all the bells and whistles I can. When I'm shooting manual I get into a more creative frame of mind. Yes, I might miss a few shots here and there, but slowing down, taking more care, thinking about settings as a scene unfolds and being able to adjust on the run takes practice and is a skill I'm really enjoying developing. And I suspect that it will be a lifetime's work, which is also an enticing challenge.

6. Creative vision

Earlier on I described how my street photography journey started when I felt my own photos had stopped reaching me emotionally. I'd spent years developing my abilities to create technically perfect images, both in the camera and then on the computer in post-processing. Many people look at these images and react positively to them, but there was something missing for me. And that's the point here – missing for me. Photography is an inherently creative process: you are capturing a moment in time, fleeting, and to anyone else other than you, in that spot at that precise moment, invisible, unless you capture and then publish the scene as you saw it. And my images were not evoking feeling or passion in me, so photography was losing its joy.

One of the luminaries in the street photography world is Valérie Jardin. I've read her book *Street photography – creative vision behind the lens* a number of times, and I've heard her speak on several podcasts, mostly about her creative process and very little about her kit. There seems to be a pattern among many street photographers: get a small, unobtrusive camera that you can master technically so it becomes a part of you and so that you, as far as possible, can stop having to think about the settings, and allow your focus and concentration to be on the scene in front of you. It doesn't matter what the camera is, it's the doing that's important: getting out there, taking shots, pushing yourself to see differently, to interact, to capture those fleeting moments and record them forever within your own art.

It's the model of unconscious competence applied to camera craft, and one which I've embraced and am still trying to master as I venture out onto the streets in search of images that evoke feeling. I try to capture and make images which have a story, where the actors are either interacting in a manner that makes me ask questions or evokes a response in me.

A line in *America*, the song by Paul Simon goes :

Laughing on the bus, playing games with the

faces

She said the man in the gabardine suit was a

spy

That's what I want my street images to do: make you stop, think, and ask –
What was that person doing? Where were they going? Were they happy or
sad? What was happening in their life at that moment?

As you explore the images throughout this book, please *"play games with the
faces"*, which leads me on to…

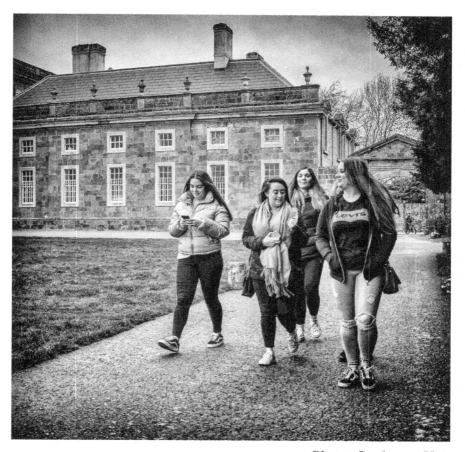

Chat at Castletown House

Chat at Castletown House *is one of the few images in this book taken outside Dublin city centre. The grounds of this Georgian stately home are just a few minutes up the road from where I live, and we came past these girls on the way back to the car after a leisurely ramble around the front field. Just shows that there's always a shot to be had, so keep your camera to hand until you are in the car!*

7. Storytelling

"Great photography is about depth of feeling,
not depth of field."

— Peter Adams

One of the oldest forms of human communication and knowledge sharing is storytelling. Since cavemen sat around the fires, huddled together for warmth and companionship, we have told stories to make sense of the world around us, to pass on knowledge, create happiness, sadness, fear and hope. To express love.

And ever since 1839, which is when Louis Daguerreotype captured the image *Boulevard de Temple*, which is generally accepted as the first photograph with human figures, we have sought to capture other people around us, either as classic portraits or interacting with their environments and one another.

We are social beings, and until science opens up mind-reading and telepathy, we each exist in our own reality, our own mental landscape of thought, emotion, experience and feeling. And yet, a constant for all of us is to imagine how others are feeling, thinking, reacting, as we project our own thoughts onto those we see around us.

And this is where street photography is so powerful, as it captures scenes and strangers, most of whom we may never again encounter, as they pass through our lives, brief intersections in time, but forever caught in the instant of our shutter release

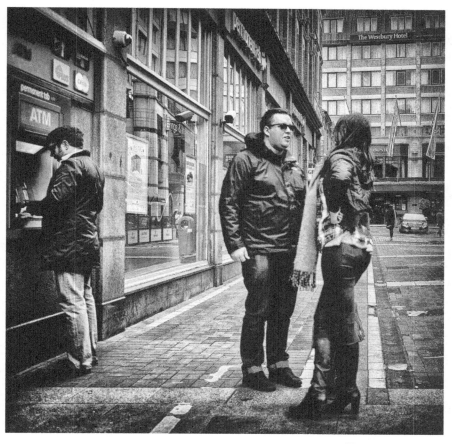

Shooting the breeze

Shooting the breeze is one of my favourite images, and one of the first street shots I ever captured as I wandered down Grafton Street. To me, there's a real connection between the conversationalists, offset by the isolation of the man at the ATM with his back to them, and compositionally, the lines of the pavement and building move the eye towards the faces of the couple talking.

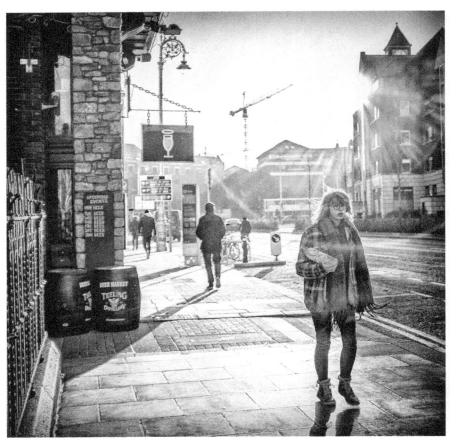

Girl contre jour

Girl contre-jour was a very intentional shot which I left home hoping to capture
that day. Hard light – the kind you get with strong sunlight low in the sky early
in the morning, offers the street photographer endless possibilities for blown-out
highlights, great contrasty scenes and, here, strong shadows, backlit hair and
lovely flare. And yes, I'm breaking the rules again placing her walking out of shot,
but for me that adds to the story for this image.

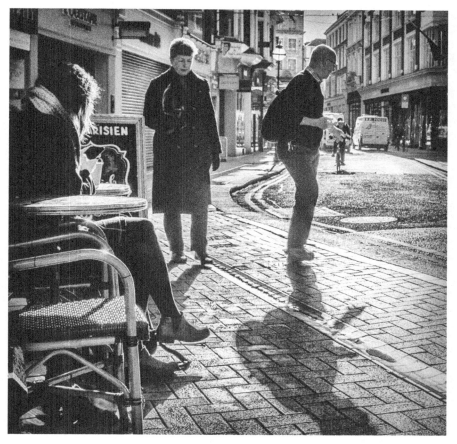

Attention caught…

Attention caught *is another image shot contre-jour using the early morning sun to backlight the figures. The lady sitting on the left had caught my eye and I had knelt down to frame her when the couple arrived. Then the man's attention was pulled back by the passing cyclist, making a lovely moment to capture. Again, strong directional shadows and the texture of the cobblestones and road all add to the story.*

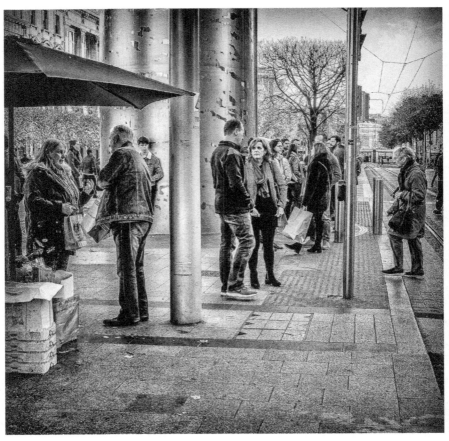

Stories at The Spire

Stories at The Spire *is a shot I come back to time and again. Maybe it's the fact that there are many different people in shot, all interacting in different ways, but I love wondering what they are saying to one another. For me the man stepping into shot from the right makes this one. He's in motion but alone, being watched by the lad leaning against The Spire but otherwise ignored, isolated as so many of us are in the hive-like spaces of the city. The Spire is a great place to hang out as a street photographer, as there's always a mix of locals and tourists milling around, and rarely have I gone and not come away with a shot or two I'm happy with.*

8. Black and white

I've chosen to shoot all my street images in black and white. I shot a few early on in colour, but monochrome just seems to evoke more emotion in the images for me, especially when I process them with a slightly gritty feel, which is a look I'm coming to like. As much of my street imagery is urban, and includes stone, pavement and texture, the tones and contrast of monochrome add to the feeling I'm trying to evoke in a way that colour shots don't seem able to.

Another aspect to this is that I'm actually colour-blind. This does impose some problems around post-processing, especially when I'm trying to alter white balance, for instance, or tweak colours. They look great to me, but as soon as Penny my wife (and an experienced graphic designer) looks over my shoulder, she winces and I know I've created some nightmare of clashing colours.

So mono is safer, as well as playing far better to the look and feelings I'm going for.

I have the option on my Fujis to set the camera up to display the live view and images on screen in mono, and I've found that this really helps me focus on shape and contrast. Seeing in black and white is a quite different way to visually process a scene, and having the camera shoot in this mode helps me "see" in this way far more easily than having to mentally convert out of colour to mono. I'm trying to learn a new visual language in black and white, and getting to a point of thinking in monochrome is made much easier with the camera helping me in this manner.

As I began to shoot in this mode, I was still attempting to apply many of the approaches I bring to my colour photography, especially around ensuring a full tonal range being captured within the bounds of my camera's dynamic range. Checking my histogram when I'm shooting landscapes in colour is almost second nature, so I was doing the same thing to my black-and-white street shots, thinking about my shadow detail and not blowing my highlights.

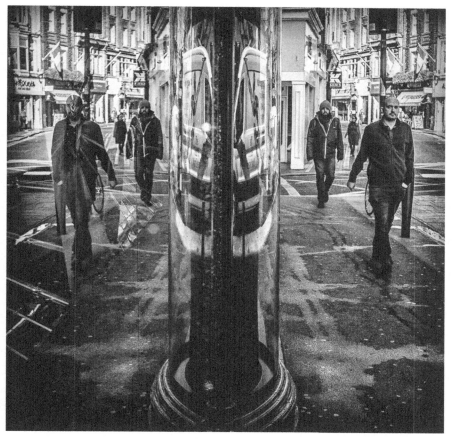

Fractured reality

Fractured reality is a reflection shot, but what pulled this one out of the normal for me is the broken window on the left, which is precisely aligned with the front man's face. I also like the rounded glass pillar, as it makes for a different look to the normal straight line down the centre of this type of shot.

But again, the rules are different for street. Creative decisions made for colour landscape, or for studio portraits, are not the same as those for street monochrome images – or at least they don't have to be. And this is at the heart of the creative process: there are no absolute rules. There's just what takes you to images that match your inner vision of how the scene you framed and captured should look on the final screen or print.

I've found that for the look and feel I'm seeking in many of my street images, crushing the blacks and allowing some of the highlights to blow out to white gives the high contrast look that renders scenes as I want to see them.

I've never been a fan of vignetting in most of my landscape work, but again, for the current street shots I'm producing, the edge burn which Nik Silver Efex offers adds atmosphere, which is lacking without it. Of course, that's not to say this will continue – but isn't that also part of the creative process: using different techniques, looks and styles as your own vision evolves and changes?

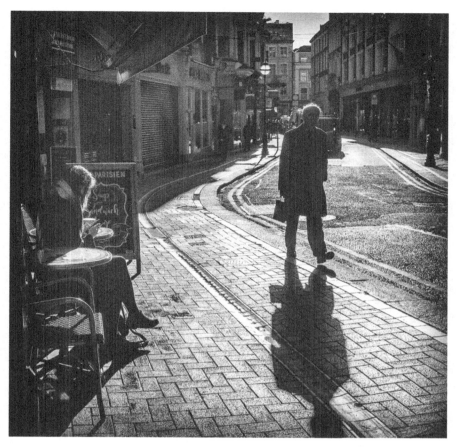

Morning routine

Morning routine *is another from the same morning as **Attention caught** a few pages back: a 40-minute shoot before a day's training I was delivering in town. In this one I've crushed the blacks even more to really bring out the backlighting of the hair on both figures. The man is almost silhouetted, just a hint of detail in his face, and his shadow is a strong leading line into the frame as he moves down the road, mid-stride.*

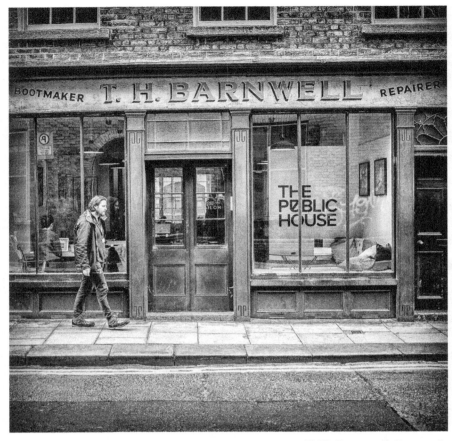

T.H. Barnwell, Bootmaker

Dublin is an ancient city. Wander the streets for long and you'll come across some old shop front that harks back to a bygone age, like this frontage near Christchurch that now houses some kind of design house. It's gratifying that they've had the sense to retain the wonderful old facade. How many people have passed through that door for boot and shoe repairs over the years, and what lives have been lived out in the building and rooms above?

9. Workflow

Until I began writing this book, my primary channel for sharing my street work has been through an Instagram account I have called *totpics*. In the same way that the 23mm fixed lens on my X100s acts as a constraint (although the more I use it, the more this is actually becoming a freeing aspect of the camera to me, removing the need to think about other possible focal lengths), so too does the native square format of Instagram posts. Rather than see this as a negative, I've embraced this as a part of the process, and visualize, shoot and process to the square format.

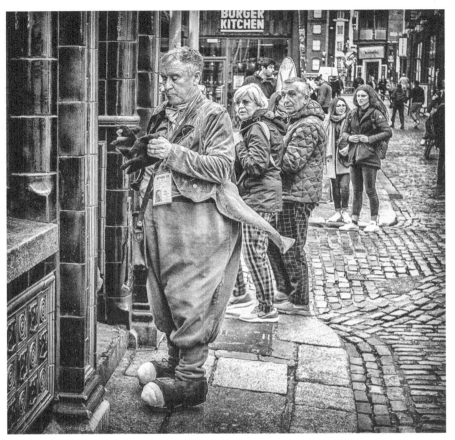

Working the street

This street performer was taking a break in Temple Bar one day, attracting curious glances from passing tourists with his costume. What caught my attention though was his tired expression, which seemed to mirror the grey damp day.

In almost all cases, I have been happy to go with a square version of the image, but the beauty of digital is the ability to retain the original image, and also to create other formats if the subject demands it. *Working the street* - the image of the clown with passers by looking at him on the previous page was one shot where square worked fine, but another shot from that sequence taken a few seconds later required a landscape format to work, so I processed that in the wider format but didn't include it in my Instagram feed.

I recently discovered that my X100s has the capability to shoot in square format, as long as I have JPG as an option enabled for file saving. I ALWAYS shoot RAW, but could shoot JPG and RAW to get the square crop shown on the live-view. However, I still like to frame up using the normal landscape format and then crop to square in Lightroom during my post-processing.

9.1. Shooting

My normal workflow is as follows. When I shoot street, depending on the light, I typically shoot at f/2.8 or f/4, in either full manual mode or sometimes aperture priority with my ISO set to auto with a top limit of 6,400. I dial in -⅔ EV to keep the shadows dark and protect my highlights from blowing out. On very bright days this sometimes plays havoc with the automatic metering, in which case I switch into full manual mode.

9.2. Lightroom processing

On returning home I immediately fire up Lightroom, and import the day's shots into a folder on my Mac. I also pop the battery out of the X100s and swap it with a fully charged one sitting charged up in the charger. This ensures that the next time I grab it I'm not going to get a dead camera – as battery life is one of the few weaknesses of the X100s.

Lightroom is not the fastest programme at importing and processing images, especially since I convert my raw .RAF files to .DNG as part of the import, and also have Lightroom build 1-1 previews to aid in the speed when moving between shots to cull and do my initial star ratings.

After the import, I have a folder of .DNG files with duplicate .JPGs alongside each one. The DNGs are in colour, the JPGs in mono. I have created a filter in the Library module to just display .DNG and .TIF files, so I apply this, select all the files using Cmd A (use Ctrl A on a PC), then apply a user preset I created titled B&W Strong 1. This pulls highlights, pushes shadows and clarity and slightly adjusts the black-and-white point. Having selected all the files, the preset is applied to every one – in just a few seconds.

In a recent release of Lightroom a new slider – Texture – was added, and since then I've replaced my Clarity adjustment with a similar-strength Texture bump, as it offers a better output restricted to areas of high detail while leaving sky and skin mostly alone.

This gives me a good starting point to begin once I've selected my images to process, which I do next. In the Library module, I bring up the full-size image in the Lightroom window, hit Shift Tab to close the side panels, then L twice to turn "lights out". Now I just have my images on screen at almost full size, and I can go through the whole shoot using the arrow keys, hitting X to mark scrap images for later deletion, and 1 for images I will return to for processing. I leave images that don't jump out as good enough to process, but which aren't so bad they need to be deleted with no star rating. There are times when I've gone back to these to find another shot from a sequence, for instance.

When I reach the end of the shots – and this doesn't take long, as I typically only spend a second or two on each image – pressing L again brings the lights back on, and Shift Tab restores my side panels. G puts me into grid view, then Cmd Delete trashes all the images I marked as X, removing them from my catalogue and also hard drive – freeing up space I don't want to waste on shots I'll never use.

Now the fun starts: processing! At different times I try different looks for my shots, but recently I've been moving towards a gritty look with burned edges to the shots. This appeals to me and brings a consistent feel to my images. For years I've heard experts on photography talk about "finding your own voice", or visual style, so that when someone looks at an image they can immediately say – Ah yes, that's a Joe Houghton. In the same way that we do for images by Annie Leibovitz, or Henri Cartier Bresson, for instance. Not that I'm ever going to be anywhere near these stars of the photographic firmament, but hey, we all have to start somewhere.

When selecting images to process, and then as I start the post-production, I try to bring out the key people in the image, and often choose images from a sequence where I've managed to catch some eye contact, and/or the elusive foot just about to touch the floor – the "decisive moment", made famous by Cartier Bresson.

Pressing R in Lightroom takes me straight into the Develop module and opens up the crop tool, where I select the 1-1 ratio and then find a pleasing square selection. I might rotate the selection slightly to fix my verticals. To do this, hover the mouse pointer just outside the crop lines so you get a double-headed, curved arrow, then move the image until the lines look right. Once I've hit the Enter key to confirm the crop, I do a scan of the edges and corners for intrusive or distracting elements. I have Lightroom set up with a black background for the photos when in Develop mode – just right click on the background area to choose the shade displayed there.

9.3. Processing in Nik Silver Efex Pro 2

Once I'm done in Lightroom I select the image and then open a copy with Lightroom adjustments in Nik Silver Efex Pro 2. I've created a set of toning recipes that I start with before adding local adjustments as needed by each photo. What I find Silver Efex does really well is add a silvery, high structure look, which I just can't get in Lightroom, and I also like the edge burning option.

9.4. And finally...

All done, save, and back into Lightroom. Final steps:

- Make any final local adjustments to the image.

- Add relevant keywords specific to the shot, including "street photography", which is picked up to add this shot into a Smart collection of all my three-star, square images keyworded street photography.

- Make sure my metadata preset is applied to add my name, contact details and copyright.

- Press 3 to give the finished image 3 stars, then B to add it to my default print photos collection, which auto-synchronises the shot into the cloud, then onto the next shot.

For how I manage my Instagram workflow, which is where most of these images end up, check the section on Instagram below.

10. Instagram

My primary outlet for street photographs is Instagram. You can follow my street work at www.instagram.com/totpics. Please do drop me a comment if there's an image you enjoy or speaks to you – it's always great to hear that viewers have connected with an image.

Once I've processed my images in Lightroom, I add them to a collection that is set to synchronize with the cloud. This means that a few seconds after I've finished my processing on my Mac, the image appears – as if by magic – on my iPad and iPhone in the Lightroom mobile app.

A quick save to Camera Roll makes the image the latest one there, so when I now open Instagram and click on the + icon it is automatically selected. I don't do any processing in Instagram – all that's been done earlier in Lightroom and Nik Silver Efex, as covered previously in *Workflow*. I try to put a short story or a few words about the image with it, and always include the technical details, as when I teach this is often asked for by my students. Shares to Facebook and Twitter save me doing that and give the image a wider audience. Then I'm done. I try to post most evenings – peak engagement time for my feed is 9pm, so ideally I try to post around 8pm if I'm settled and have a few minutes.

11. Time

"Don't wait. The time will never be just right."

Napoleon Hill

Photography is not my main job. I have a family and small children with all the demands these entail. I lecture at university in business and project management, and consult in businesses and non-profits – that's what pays the bills. I also train others in photography, which can mean any form of photography from landscape to portraits, product shots, sport – whatever my clients want to work on, and do longer term photographic mentoring and development with one or two people each year.

So when it comes to my personal photography, which street photography is, time is at a premium. I have to consciously carve out opportunities and then make the most of them, as this time is difficult to find.

And this was perhaps what was at the heart of the challenge that coalesced around the size and weight of the DSLR kit. Unless I opted to carry heavy kit around as I went about my other activities, I found that in the little spaces of time when I might have got some frames in the bag I didn't have anything other than my phone with me. As discussed earlier on, the phone just doesn't cut it for me – at least for now until technical limitations and form factors change.

So I've begun to leverage my business consulting in town to help me find some time to do my street photography. The consulting contracts are taking me into Dublin anyway, so if I am intentional with my time, I can build in some street photography in around the working time.

Catching the bus immediately offers possibilities – see *Absorbed* in section *14. Secret shooting*. And even though it's typically only five or 10 minutes' walk from the bus stop to the office once I'm into town. That's time I can sling the camera around my neck and take a few shots as I walk with the rest of the commuters. If traffic is light, I'll even get off a stop or two early to give myself some extra shooting time, and I also vary my route so I'm walking unfamiliar streets to open myself to new photographic opportunities.

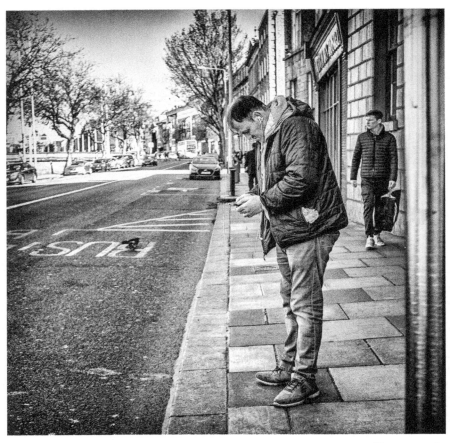

Concentration

Concentration was taken as I was waiting for the bus home one evening on the Quays near the Four Courts. Using the pole on the right as a partial frame, the line of the kerb bisects the image with the man facing into the middle of the frame. The line of the road moves they eye towards the top of frame, where his head becomes the focus of attention. Another example of the fixation so many people in public now have on their mobile phones.

Lunchtime is also fertile shooting time. The light is different to earlier in the day, and exploring the back streets around wherever I am consulting often sees me exploring places I've never been before. Walking a city in this way is a fabulous way to really observe detail and the fabric of the place in a way that travelling in a car or bus passes by. And now and then I'll invite a co-worker to come with me, especially if they are local, or a fellow photography enthusiast. I'm always fascinated at how we all see the same scene differently – picking out different elements, angles and compositions, so that even though we've walked the same route, we can end up with quite a different set of images.

At the end of the day, new light again. Camera in hand, I exit the office to capture and record the denizens of the city going about their lives. Wet or dry, winter or summer, the light is always right if you make the most of what you are offered. Although, I do love shooting after rain. The shine off Dublin's cobbled streets makes for beautiful contrasty shots in these conditions, and there's always the chance of a low-angle reflection to add to the normal height captures.

12. Hard light

As I learned the "rules" of photography years ago, one rule that came up many times was that the "best" light is around sunrise and sunset. This is what landscape and portrait photographers call the "golden hour". And for many types of photography, that is a good general rule to follow to get beautiful images with golden, soft light, and wonderful skies filled with riots of amazing colour, or soft, warm outdoor portraits. But not for street photography!

Street photography is different, so the "rules" are different. Some of the very best times of day, and the best light for street photography can be when there is "hard" light: full sunlight, sharp, well-defined shadows, high contrast, gritty texture on walls brought out by strong directional light.

When I head into town for a day of work, depending on the time of year, the sun is just coming up, or is still pretty low in the sky. Walking up the hill from the Quays towards Christchurch at around 8.30am, I'm facing into strong, directional sun coming from the city skyline, throwing wonderful long, hard shadows, and giving people walking on the streets fabulous backlit hair and rim lighting. The spring and summer months can be wonderful times for getting out in the middle of the day, when other photographers might be bemoaning the lack of "good" light. There's always good light: it's just what you do with it.

12.1. Dynamic range

Hard light also brings with it some challenges, of course. Bright sunlight presents a constant problem for street photographers, who are generally trying to capture a scene in one frame, as opposed to a landscape shooter, who may well be able to bracket their exposures and do HDR (high dynamic range) merging in post.

In street, we typically have to decide as we take each shot whether we want to protect the highlights or the shadows. Either is a valid decision – it all depends on the outcome you are looking for. If we protect the highlights, exposing darker to ensure that we retain detail in the brightest areas of the frame, the corollary is that the darker areas will typically be "crushed". That is, the blacks will go completely black and you may well lose some of the details in the shadows, even shooting RAW and with the amazing capabilities of software these days to rescue images.

And the opposite is true. If we want to make sure that we retain all the wonderful details present in the darker areas of the shot, then we'll need to over-expose, to make our overall image brighter, which will "blow" out the highlights to complete white.

12.2. Shooting to the right (or not)

Experienced digital shooters learn that there is typically far more latitude for recovery of detail in shadow tones than from blown-out highlights. So a technique called "shooting to the right" is popular for maximizing the dynamic range your camera is able to capture in a single frame.

Most modern cameras, and certainly all the mirrorless ones, allow you to display the histogram in the viewfinder as you are composing your shot. This is a HUGE benefit when confronted by scenes where the range of contrast is close to or exceeding your camera's ability to capture the full range of tones. When you look at a histogram, the curve indicates the tonal values in your image. Peaks to the right indicate brighter areas, with the right-hand edge being total white, where you start to lose details as your highlights blow out. Peaks in the middle are mid-range tones, and to the left are dark tones, with complete black on the very left edge.

Knowing this and seeing how the spread of tones appears in your histogram as you look at the scene with your current camera settings, allows you to make decisions. Can you fit all the tones within the bounds of the histogram and not blow out any highlights or crush any blacks? OK, then you can probably get a "well exposed" shot.

But a "well exposed" shot may not be what you are after. Maybe you are trying for a light, airy look where blown highlights are fine. In this case you can adjust your settings and purposefully move the histogram lines to the right and render the sky or background completely white. Or perhaps you want a *film noir* look, with deep velvety shadows. In that case, adjust your settings to move the exposure histogram to the left and butt the lines right up to the left-hand edge.

There's no absolute right or wrong here: this is art, not science.

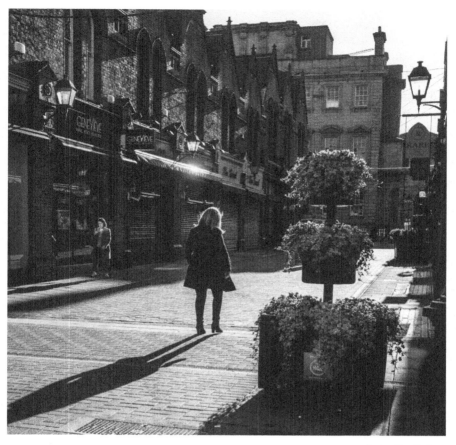

Into the light…

Into the light *is one such image. The black shadow cast by the lady walking into frame leads the eye into the shot, supported by the lines of the street around her. Blacks are crushed deliberately to accentuate the contrast in highlight areas, and this also brings out the lovely up-light on the second figure's face nearer the shops to the left. The outline of the street lamp on the right is sharp and mirrored across the street by the one above the shopfront. A colour shot would have had a completely different focus – probably more on the flower baskets front right.*

13. Composition

As with any genre of photography, the way elements are chosen and placed within the frame, the varying weight, colour and tones, lines and movement – all these factors combine to create composition. Merriam-Webster defines composition as *"arrangement into specific proportion or relation and especially into artistic form"*.

The following pages explore different types of image I've assembled so far in my explorations into street photography, with examples of each, all shot on my perambulations around the streets of Dublin.

Although most of my outings tend to be unscripted, sometimes it can be good to concentrate on a specific type of composition or theme for an outing, to go and consciously try to "see" that type of image. Why not try it and see if it works for you?

13.1. Interactions and conversations

"Photograph the world as it is. Nothing's more interesting than reality." Mary Ellen Mark

If storytelling is at the heart of strong street images, then interaction and conversation between people is a key element, bringing a sense of mystery and discovery. With our images we try to communicate a scene, a feeling, a sense of place and time, and when these images include chat between those within the scene, the viewer is drawn in. *Shooting the breeze* is one of my favourites of this type of shot, taken on Grafton Street, but I also love this next image of the two guys chatting as they walk across the Liffey *On Father Mathew Bridge.*

I titled the gallery "Interactions" on the website. The images can be seen at: **https://www.houghtonphoto.com/streets-of-dublin/#interactions**

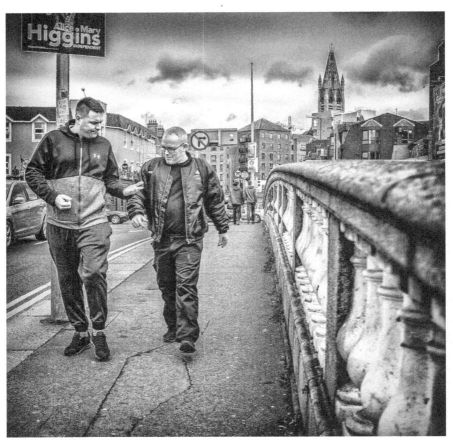

On Father Mathew Bridge

On Father Mathew Bridge *What are they talking about? Are they making plans, arguing, sharing a secret? We naturally start to make up our own stories about their lives, which is another way we connect with them and each other. The bridge stonework on the right leads the eye into frame with a shallow depth of field also taking the eye back towards the plane of focus in line with the guys., Finally, a little negative space bottom left for the two to walk into leaves room for their movement to flow in the mind of the viewer.*

13.2. Passing by …

The street is constantly in motion, especially in urban settings, and it's this ephemeral nature of life passing by that makes street photography such a constantly inspirational genre to engage with.

"I really believe there are things nobody would

see if I didn't photograph them."

Diane Arbus

The Passing By gallery of images can be seen on the website at :
https://www.houghtonphoto.com/streets-of-dublin/#passingby

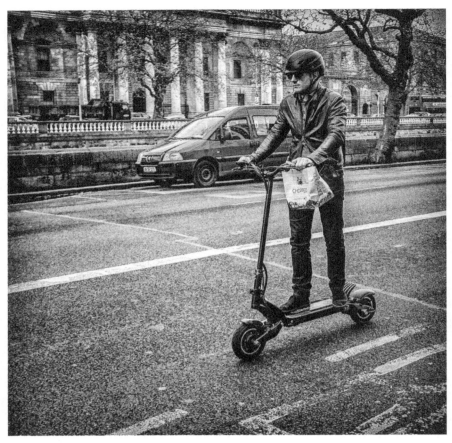

Free wheelin'

Free wheelin' is an increasingly common sight on the streets of the city – the electric scooter is becoming a popular option for commuters, although I'd be terrified of being knocked off – either by a passing vehicle or a badly placed pothole.

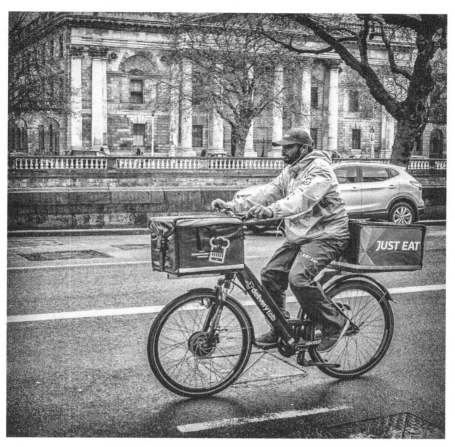

On the way

On the way, *taken in almost the same spot as the previous image, this shows another very common city sight: the bicycle delivery. I think I'd be wearing a helmet, given the Dublin traffic. Hopefully he made it to his destination in one piece!*

13.3. Archways

Why do you speak to me of the stones?

It is only the arch that matters to me.

Kublai Khan

As a framing device, archways are one of the best compositional aids for any street photographer. Naturally darkening the edges of the image, they focus the viewer's attention inwards towards the subjects walking through, as well as often bringing wonderful texture from aged brick or stonework into the image.

And archways are like doors, transition points from one place to another, portals into another place or reality, archetypal and fundamental symbols which resonate deeply with us. A sense of history often accompanies archway images, for as well as distance we perceive the receding vista beyond the arch, almost forcing us to wonder about it, about what lies beyond, what possibilities lie there.

As photographic elements, archways typically offer a darker frame through and into which we place a slice of a distant environment. Figures in frame are a clear indicator of scale, which might enhance the awe we feel at a monumental structure, or something more pedestrian like a doorway. Either way, arches are an architectural space that we almost instinctively focus on and begin to process as story: a beginning, a passageway, an endpoint. The start of a journey, the emergence into light from darkness, from sadness into joy, from darkness into light.

Archways

The Archways collection of images on the website can be seen at :
https://www.houghtonphoto.com/streets-of-dublin/#archways

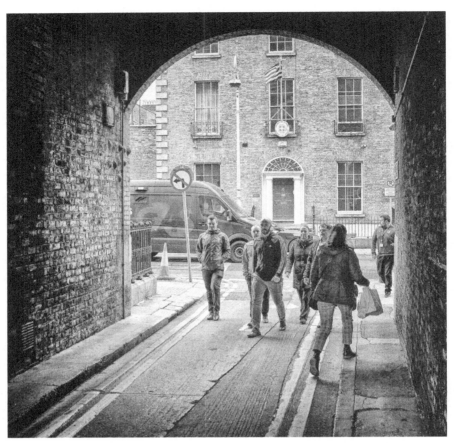

Walking through…

Walking through *is a prime example of this type of shot. This one made the cut with the echoed shape of the archway picking up from the shape of the Georgian door of the Greek Embassy across the street. Eye contact from the central man walking confidently towards me, and strong contrast from the leading lines of the street all combine into a strong image with some good tonal variations, strong compositional elements and people interest..*

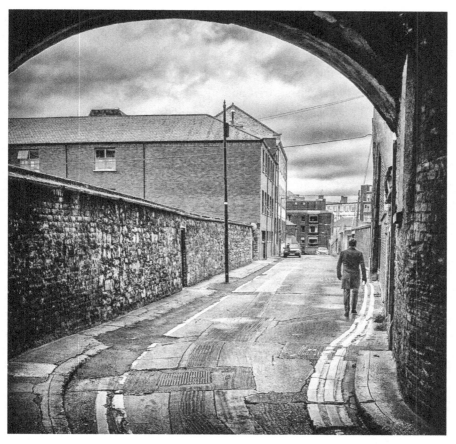

Walking away...

Walking away is another image using the arch as a frame, this time opening out into a more expansive scene, where the subject is moving away from the viewer. Lovely old stone and the patchwork of road repairs give detail, a threatening sky presages rain to come, and there's a story to be had from the anonymous man, foot just above the roadway as he walks into ... what?

13.4. Laneways

Dublin is an old city dating back over 1,000 years to when the Vikings settled at Dubh Linn, or the Black Pool, at the confluence of two rivers, where Dublin Castle now stands. There are many wonderful little laneways to be discovered between buildings, often cobbled and crooked like the one on the following page, down near the Quays.

Shots in these situations offer strong convergence lines to lead the eye into the picture, wonderful contrast and texture from old cobbles, paving stones and building brickwork (not Kublai Khan's cup of tea at all, based on his earlier quote). The tapestry of time is very evident in these roadways, with centuries of different materials making up the surfaces over which people walk, ride and drive, mostly oblivious as they move through their day.

And isn't that what we are trying to capture as street photographers: a tiny glimpse of one small part of the tapestry of time, or at least a few threads, a tiny swatch of the eternal swathe of life, worked in the loom of the universe?

It's always interesting deciding how to compose these shots: bullseye; rule of thirds; where to place the convergence; what to emphasise and what not; when to include people and if so, where in frame to place them. But that's the fun and challenge!

The Laneways gallery on the website can be found at :
https://www.houghtonphoto.com/streets-of-dublin/#laneways

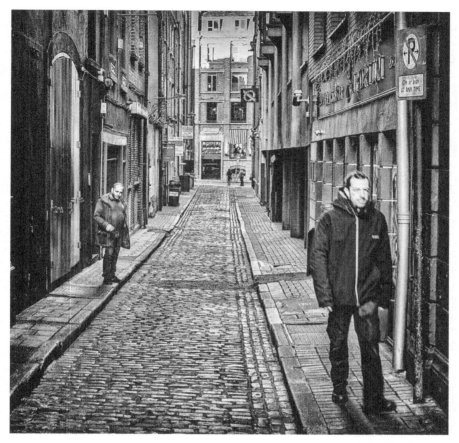

Dublin laneway

Dublin laneway shows a typical example of these narrow, cobbled streets separating many of the blocks in Dublin City centre. The quizzical gaze of the man on the left of frame draws the eye down into shot, while the man front right is slightly blurred as he moves towards the camera and out of shot. Lovely textures in the stonework of the road and patterns of light and shadows in the walls and doorways lead the eye through the image.

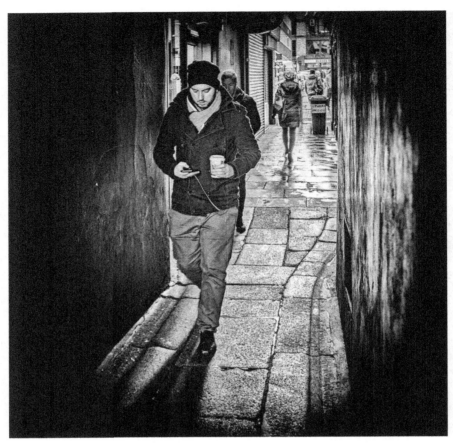

Engrossed

Engrossed – the narrow space between the two walls naturally makes for a powerful frame, especially since they are both dark, contrasting with the light filtering through on the wet paving. It's really quite sad to observe the huge number of people engrossed in their mobile phones while walking around. There will be generations of Dubliners (and visitors) who know very little of the visual story of the streets they walk, and appreciate little of the rich heritage of architectural styles that help make this wonderful city so fascinating to explore.

13.5. Overlooked

Whenever I come across a striking shop window, or wall poster with figures or faces looking down on the street, it's a good place to stop and wait to see what might happen. A lot of street photography is about recognizing the potential in a scene, and this type of scene is a natural opportunity for interesting shots to present themselves. The two figures in **Overlooked** combine here to create a triangle, another strong compositional feature.

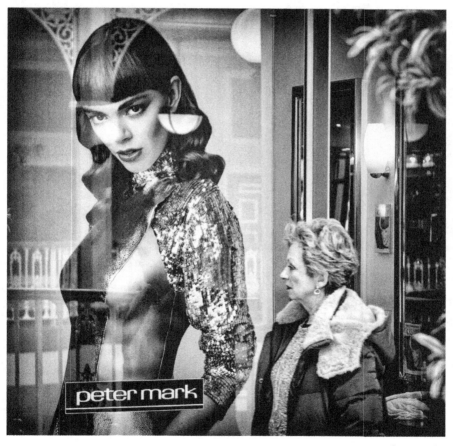

Overlooked

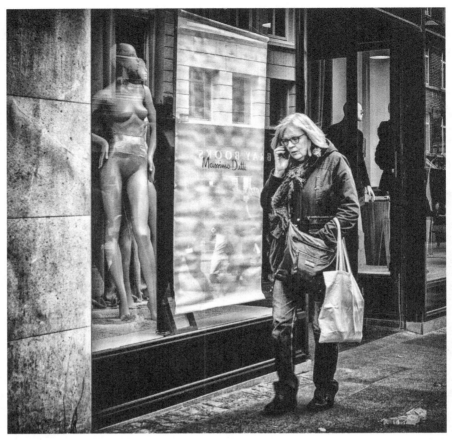

Hello?

Hello? The blank figures in the shop window contrasting with the lady walking past, reflections on the glass adding complexity to the scene. The textured wall tiles on the left of the image meet the pavement triangle in the bottom left, creating a partial frame for the woman to be walking into.

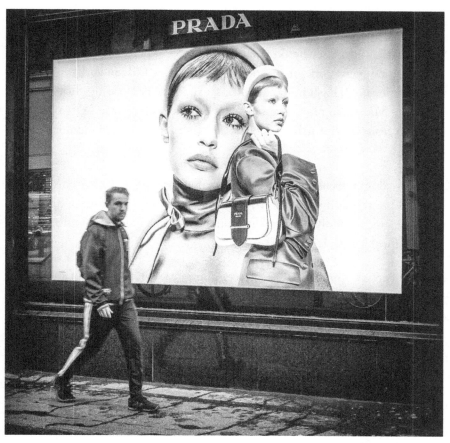

Dreams and reality

Dreams and reality *is another one of this type of image, where the impossibly perfect models staring down from the Prada window contrast with the casually dressed passerby. The dark clothing he is wearing contrasts well with the lighter tones of the billboard, and the pool of light on the ground establishes context nicely, rather than just having a disembodied window in shot. I purposely placed myself a couple of metres along the street on the other side to create the angles, so the lines expand towards the viewer, and he is walking into the scene with a curious check on me, which adds eye contact and makes the image work.*

13.6. Distance

Near or far? How close should you be to get a "good" street photo? Follow the acclaimed New York street photographer Bruce Gilden and you'll be up close and personal, flash in hand, getting candid, very close-up shots. Ming Thein is a Malaysian photographer, who often uses longer lenses to create his vision from much further back. Both create arresting and memorable imagery.

Classic wisdom tells us that focal lengths of around 35-50mm are the "best" for street photography. Cartier-Bresson typically used a 50mm on his Leica, which has undoubtedly had a great influence on this genre, but who's to say that any focal length is "better"?

The received wisdom is that, as a street photographer, the shorter focal lengths are closer to the view that the human eye sees, so around 35mm on a full frame (or 23mm on my X100s with the crop sensor). Many guides suggest that you should learn to "see" shots, framing them around this viewpoint, and that to get good, frame-filling subjects this means getting in closer, normally by physically moving yourself.

For many beginners to the field (and I include myself), this poses a serious challenge. I was brought up on zoom lenses, typically giving me ranges of 18mm through to 200 or 300mm, so I had rarely had to consider moving in, getting more personal with potential subjects. I had always enjoyed the luxury and ability to shoot outside the physical space I was projecting into, not to have to move myself into the scene, not to have to engage in a more intimate manner with the surroundings. *Really* (to follow) is one of the few images in this book shot with my Nikon D810, and I was at 70mm on my 24-70mm lens for this shot of the discussion on the other side of Grafton Street. Had I tried to move in closer, I would have intruded on the scene and it would have been lost, so there can be merit and usefulness to employing longer lenses – if you are happy to lug them around.

Really?

Really? Great interaction between the two men in this shot, eye contact, expression – a real moment in time captured. Use of a shallow aperture also separates them from the slightly blurred background.

So although moving with your feet and using a 35mm equivalent field of view is definitely a constraint, I've come to realise that there is value in this approach, even though it can be mentally challenging at times. This is how we grow in any field – try new ways of doing, face fear and stretch boundaries, accept new modes of working, even though these at first may seem difficult or alien. I have been amazed at how my eye has adjusted to the 35mm viewpoint, so now it is becoming natural to mentally frame scenes I encounter in this way. In fact, when I was out the using the Nikon 24-70mm the other day the scenes looked "odd" until I realised I was composing at 70mm!

13.7. Leading lines

A common but nonetheless very powerful compositional element, leading lines move the eye of the viewer through the frame, taking attention from one part of the image to another.

Lines can be very clear and straight – the classic train tracks shot converging to a point way back in the distance is a good example, or not straight at all – the S curve is a very powerful organic shape that can be used to great effect with a windy road or river. Lines might be far more subtle. For instance, gestalt lines where the physical line is not present, but a set of elements combine to create a visual pathway. A clearly directed gaze, if strong or clear enough, could also be sufficient to take our viewpoint across a frame, or even out of it. Images such as this can evoke questions: What is she looking at? Why is he fearful? What's coming that she can see and we can't?

And if the image causes the viewer to ask a question like that, you're telling a story. You've hooked their attention and engaged them in your narrative. You've made them participants in the scene.

For a story to work, be it through words or in an image, some kind of journey is required. It might be a physical one – a movement from A to B, or it might be a mental one, where our preconceptions are challenged, or we are shocked by the realization of what's in front of us, or where we've come from to arrive at this point. Leading lines facilitate this journey, and as we compose and make our images, both at the time of taking the photo, and also in post processing, recognising and then accentuating leading lines is a key skill which every visual storyteller has to attune themselves to, practice and continually develop.

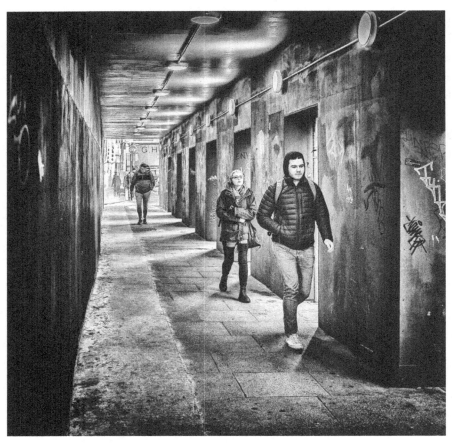

Following...

Following... could fit in under the sections on archways, laneways, leading lines or shadows and light, but there are certainly leading lines making up a key part of the composition, so we'll leave it here. I was out walking up from the Quays to Dame street when I came across this temporary tunnel, built to protect pedestrians from building work, and it was one of the times when the size of my little Fuji enabled me to get the shot. It was raining that day, so I didn't even have my camera out, but it was in my messenger bag – as it always is these days. As soon as I saw this scene I stopped and whipped it out, and waited for some people to walk through. Happy days – a keeper!

You lookin' at me?

You lookin' at me? Shows the power of a lower angle when shooting a street scene. Kneeling down accentuates the convergence of the street lines and, in the case of this shot, allowed the pool of light to fill the centre space of the frame as the pedestrians walked along, mostly taking the outside line like this chap did to avoid me behind the camera. A damp morning brought that lovely shine out of the paving, and really pulled out the textures of each brick on the ground.

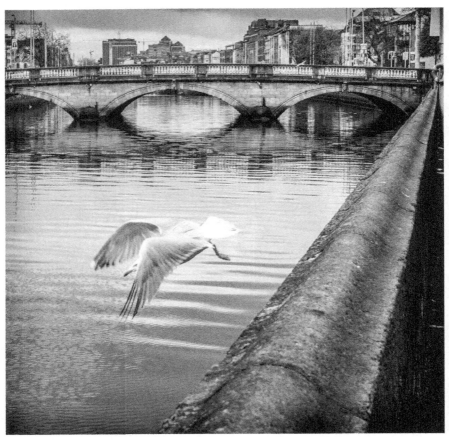

Fishing on the Quays

Fishing on the Quays – a rare one for me – no human figures in this image, but strong lines from the wall along the Quays and the Father Mathew Bridge frame the gull as he launches down to the black waters of the river Liffey in search of some morsel. I liked the way the water bottom left was ruffled by a passing breeze and moves the eye up towards the bird's outstretched wings, its beak and eye providing a clear pointer to its out-of-shot destination.

13.8. Reflections

I love working with reflections. Reflected scenes look different, often subtly distorted, and there are so many opportunities when shooting street to utilise them – shop windows, mirrors, puddles after rain. And bright lights can really stand out in a reflection at night, with the distortion adding interest.

13.8.1. Polarizing filters

Although I rarely use one when shooting street, a polarising filter is worth keeping in your pocket when out on a shoot, as it can either enhance or almost eliminate reflections as it is turned in front of your lens, so in some situations this might give you options that are otherwise impossible to achieve.

13.8.2. Puddles

Puddles are brilliant for really eye-catching images. The trick is to get your lens down as close to the water as you possibly can. I carry a little 4" square Z-shape folding tripod, which I can fix to the base of my Fuji and submerge in a puddle up to about six inches deep to keep the camera just above the water, and this has given me a few super shots of this type. But if you don't have a stand, just get down as low as you can. A flip screen really helps here, so you can compose your shot and keep your horizon line straight.

13.8.3. Position

Be careful where you position yourself when shooting any reflection, as you will find yourself appearing in-shot, like Ben and I in *Taking a break...* two photos on. That's fine if you *do* want to be part of your scene of course.

13.8.4. Up or down?

When composing your shot using a puddle, river or other water source, consider whether you need to include the whole scene, or if just the reflected image might be more effective. Sometimes, for instance, a building shown in the ripples of a river can be very powerful, rather than a more "normal" shot with the building in the air and also upside down reflected in the water. Experiment with compositions and see what works best for the scene you have to work with.

13.8.5. Layers

Be cognisant of layering whenever you shoot reflections – especially through glass. Different elements in your scene will appear sharper or almost ghostly, and playing with different settings as well as adjusting your position to get different angles can dramatically change your final image.

13.8.6. Camera settings

Keep an eye (no pun intended) on your focus and aperture combination. Selecting a shallow depth of field will de-focus some elements in your scene. So, for instance, you might pre-set manual focus out to a few feet with an aperture of $f/2$ to get a sharp shot of someone in a café when shooting through the window from outside, while blurring the reflections in the glass as well as the background. Alternatively, selecting $f/16$ in this same instance would probably render both your subject inside the café sharp as well as the details reflected in the glass. Two very different images would result. Always think about what it is you want to end up with as you adjust your settings and set up for each shot.

13.8.7. Highlights and shadows

Reflected highlights will often really stand out, especially if the interior behind the glass is relatively dark, so be aware of this when composing your shot. You may need to blow the highlights if you want to expose for the darker areas, or crush your blacks if the highlights are your main points of interest. Both can be correct, depending on the scene and your artistic intent.

13.8.8. Post-processing

In post processing, reflections or the interior behind glass can lack contrast, so play with the blacks and whites, and if you are using Lightroom, the Dehaze and Clarity sliders. These can have a huge impact – just don't overdo it (unless that's the look you really want).

 There's a great link to some super reflection images at http://www.streetviewphotography.net/top-10-reflections/

A gallery titled "Windows" has many of these images in it on the website, at: **https://www.houghtonphoto.com/streets-of-dublin/#windows**

Let's see some examples of my Reflection shots...

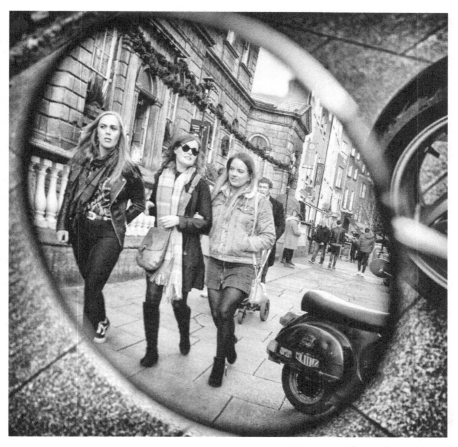

Saturday outing…

Saturday outing. *Framed by the rear view mirror of a Vespa parked up on the street. Use of shallow depth of field in this shot also separates the scene in the mirror from the edges of the frame, and I liked the way the three ladies shared the frame with the rear of another similar scooter they were passing as I pressed the shutter. The guy pushing the baby buggy behind them makes a lovely addition to the observant viewer.*

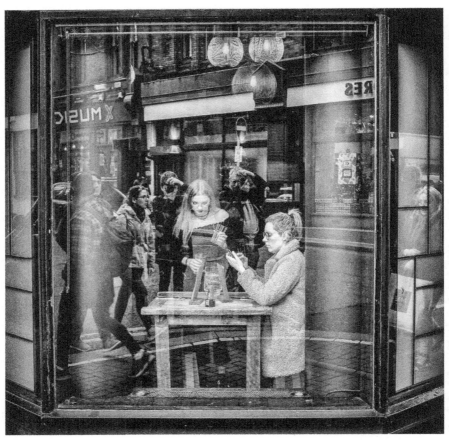

Taking a break. *Here's a very different reflection shot – with me and Ben both visible shooting as we flank the waitress in the cafe window, studiously ignored by the woman on her phone. Another little story plays out in the darker area on the left of the window, as we see passers-by caught in mid-stride. The window provides a natural frame, with the angled panes on either side moving attention towards the centre, where all the real interest lies. I normally leave these shots un-flipped so the reversed writing on street signs and shopfronts signals the reflection even more.*

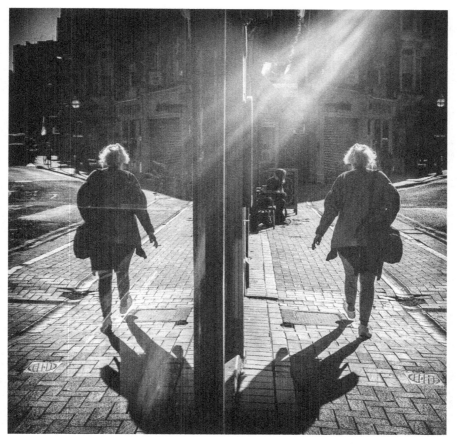

Caught by the light

Caught by the light. *Here's a third reflection shot, different again from the previous ones. Large shop windows can often provide fertile opportunities for interesting compositions. What I liked here was the strong triangles formed by the woman's black reflection converging in the centre foreground, and in the background, by the shadowed street. The mirrored image is offset by the asymmetrical shaft of sunlight leading the eye down to the seated background figure. Our walker's hair is beautifully backlit, stride caught just off the ground as she marches determinedly onwards into her day.*

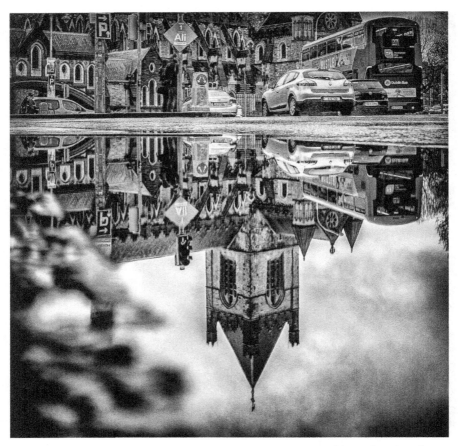

Christchurch reflection

Christchurch reflection. Rainy days provide opportunities for wonderful compositions if you are willing to get down low and take advantage of puddles and shiny surfaces. I had a lovely exchange with a taxi driver waiting at the lights next to me as I played with the angles. He was worried I would get my camera wet. Placing it on the ground just in front of the edge of the puddle makes the 18 inch little pool at the side of the road seem much bigger, and waiting for the traffic to pass gave me both a clear field of view as well as a perfectly still reflection.

Embracing the constraint of a square format here results in what is hopefully a striking image. On seeing this, my wife mentioned that for her, this crop highlighted the lovely archways and windows of the cathedral in a way that she had never seen before. Sometimes omitting major elements of a commonly shot scene can focus attention on other normally overlooked details.

13.9. The decisive moment

The classic street shot for me will always be Henri Cartier-Bresson's (HBC) 1932 masterpiece *"Behind the Gare St Lazare"*. The man jumping from a partially submerged wooden ladder trying to clear the standing water, frozen in mid-air, legs mid-stride, head and torso blurred from the movement. Enter this at a photo club these days and you would probably come away with a lot of negative critiques about lack of sharpness, movement blur, the man being off the thirds lines and heading out of shot. And yet this is one of *Time Magazine's 100 most influential images of all time*. It is the classic decisive moment shot: an instant in time, forever frozen, evoking instant responses in the viewer – What was he doing? Where was he going? Who was the shadowy figure?

It's fascinating to discover that although HCB will always be associated with the following phrase, he didn't actually coin it. That accolade goes to Cardinal de Retz: *"There is nothing in this world that does not have a decisive moment."* which HCB quotes in the preface to his now classic 1952 book *Images à la Sauvette*, which was renamed for the English edition to *The Decisive Moment*. HCB's own words, which most closely describe his thoughts are also in the preface:

"To me, photography is the simultaneous recognition, in a fraction of a second, of the significance of an event as well as of a precise organization of forms which give that event its proper expression."

One way to build the decisive moment into our own shots is to incorporate some clear time-sensitive element into your shot. When I'm taking shots of walkers, the step with just an inch or so of space under the leading foot before it makes contact with the ground is an obvious one, and also harks back to Cartier-Bresson, who used this to such great effect. *Strider* (next page) shows this technique in action. I don't know when I first saw Cartier-Bresson's wonderful image, but it's indelibly etched into my photographic consciousness, and this is – for me – the central aim of street photography. To evoke a reaction, an emotional response, a question – to engage the viewer in a mental dialogue. To have my image remembered, because it made an impression. That's what I strive for in my images as I make each one. Do I succeed? I don't know – you tell me.

Strider

Strider. *As the young woman marches confidently into shot, foot poised just above the pavement, almost but not quite making contact with the black shadow below, the lines of the street open up the image and bringing her forward into our gaze. Another early morning hard-light shot, the long, hard-edged shadows adding to the lines and movement, and juxtaposed by the traffic going in the opposite direction.*

13.10. Through the window

Walking the streets provides many chances for what they call "tooting" in the North of England, where I spent many happy years. Having a peek into people's lives through a window – a couple of seconds glimpse before you pass by, but so often giving you lovely scenes, if you are ready and willing to capture them.

A gallery titled "Windows" has many of these images in it on the website, at: **https://www.houghtonphoto.com/streets-of-dublin/#windows**

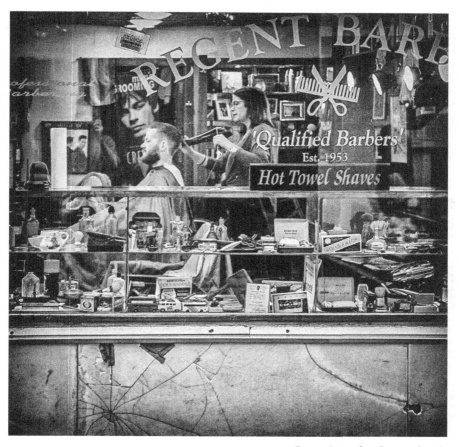

Something for the weekend...

*I've found that barber shops are a great source of such shots. **Something for the weekend** was one of my first street images shot with my little Fuji X100s on my initial foray out into Dublin to see what I might find. The busy clutter in the window drew my gaze, then the layers of interest with the hairdresser and client, overlooked by the model in the poster behind, all combined to make me shoot a few frames. I purposely included the broken wall below as it added to the gritty reality of the scene, and I like the spider-webbing of the cracks in the bottom left.*

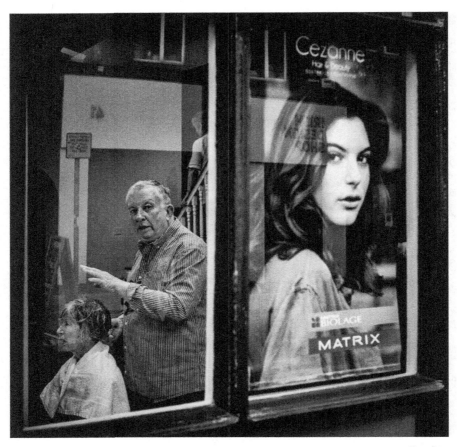

Looking

*Here's another barber-shop image – **Looking**. A poster adds to the interest with the model on the right mirroring the hairdresser through the window as he stares at me, wondering what I'm doing. I gave him a thumbs-up after taking the shot and he broke into a lovely smile: a nice moment of connection in my morning's shooting. The woman coming down the stairs in the background adds the third key element into the left-hand frame of this image.*

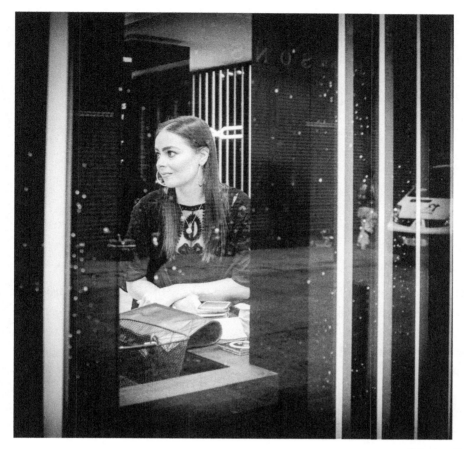

Observed

Brown Thomas was getting ready for the trading day as I passed their windows on a very fruitful (photographically speaking) half hour wander along Exchequer Street one morning, seizing some shooting time before I was to deliver a day's training in the Central Hotel. In **Observed**, I took several shots of this lovely young woman who was quite unaware of me and my camera, only three or four feet away from her through the glass. Strong vertical lines and contrast from the venetian blinds and marble, a zig-zag at the bottom of shot moving the eye into the scene, and her flawless skin and hair really makes for a shot I was pretty happy with.

13.11. Interactions

I love catching interactions between people on the street. So often these are ephemeral moments which might only last for a fraction of a second – like *Passing Glance*, to follow.

"Street Photography is like fishing. Catching

the fish is more exciting than eating it…"

Thomas Leuthard

For me this is one of the best parts of being out with my camera. You see differently when walking around doing street photography: attention is heightened, you are constantly scanning the scene ahead and around you, processing vectors of movement, the composition constantly changing and unfolding.

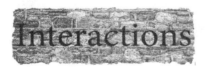

The gallery with these shots on the website is at :
https://www.houghtonphoto.com/streets-of-dublin/#interactions

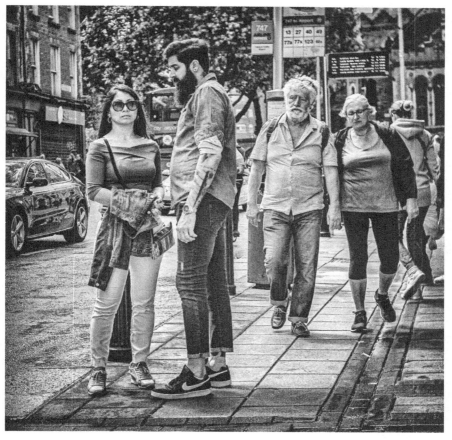

Passing glance

Passing glance. *I love the way there are multiple sight-lines in the shot – the lady with the sunglasses is looking at me, her partner is looking down at her, and the man with the beard is looking at the lady with the sunglasses – lots of activity caught in that split second as the shutter opened.*

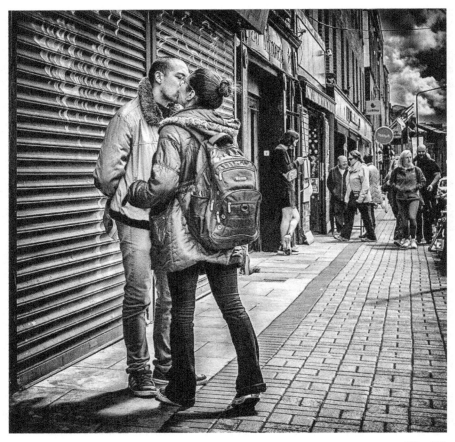

The Kiss

The Kiss *is one of my favourite shots from this project. Taken in the Liberties one lunchtime as I was ambling around, it's a great example of the fleeting opportunity that is what keeps street photography so interesting and challenging. I saw her moving in for this kiss from about 20 yards away, and took this shot walking up to them with the camera at my chest height – not even composing in the viewfinder or screen, as I didn't want them to become aware I was shooting. I was at 1/1000th sec, f/4 with the Fuji X100s here.*

Stretch kiss

Stretch kiss *is another one I like: the simplicity of the stone around them, she's up on tip-toes and cool dude taking a moment away from his phone to respond to her.*

13.12. Moments

Like Interactions, the photos here in Moments are fleeting, literal moments in time caught by the shutter. I suppose that's actually what any photograph is, but these images hopefully capture or evoke a story, but perhaps not specifically an interaction between people.

"Photography is the beauty of life, captured."

Tara Chisholm

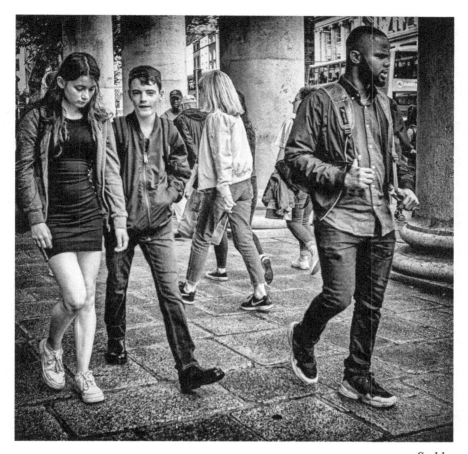

Sad lass

Sad Lass *was caught walking with a confident young man under the columns of the old Central Bank opposite Trinity. It was her expression that caught my eye when going through the shots from that day: downcast and sad, a very different feeling to the stare of the lad next to her.*

Feed the birds

Feed the birds *is a classic moments shot – the old lady throwing crumbs to the flock of expectant gulls clustered around her in St. Stephens Green one very hot summer's day. I picked this one from a few that I shot, as I like the outstretched wings of the gull in front of her, backlit feathers clearly delineated as the sun lights up the wings from above. The dark foliage of the trees sets off the white of the birds, all looking at the lady to see if they have a chance of any scraps.*

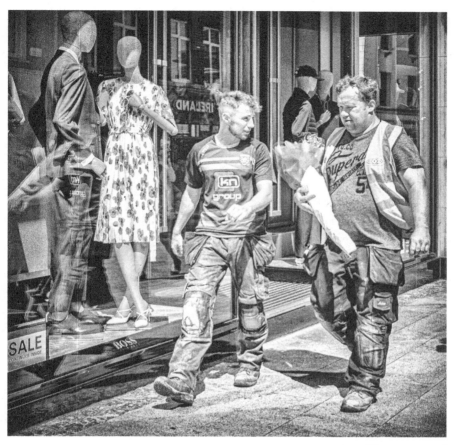

Flowers tonight

Flowers tonight. *Gotta love this one! The two big, brawny guys counterpointing the immaculate shop mannequins, Supermac on the right holding a lovely bunch of flowers. What are they discussing? Where are they going? So many questions and possible stories ...*

13.13. Shadows and light

Reviewing my shots for this book, I was struck by how almost all have people in them. As someone who has spent many years shooting beautiful landscapes with typically no human figures included, this has been something of a revelation to me, but I am beginning to see that it is only after you begin to build up a body of work that patterns and a signature "look" emerge.

13.13.1. Fishing

You can simplify some of the chaos of movement in street photography by removing one element: your own movement, by taking a position and then waiting for people to walk into your scene. Olaf Sztaba demonstrates this technique in some of his excellent videos on YouTube as he travels the cities of the world shooting street. Looking out for light – perhaps a patch of sunlight in shadow, then waiting for figures to enter it can be a fruitful technique that he has mastered and I'm really only just starting to explore.

The Spire from Henry Street

__The Spire from Henry Street__ is a well-known view of Dublin, this rendition on a wet and windy morning where the grey skies hung ominously over the city – but great for street photography as the rain and wet paving made for lovely reflections and contrasty shots.

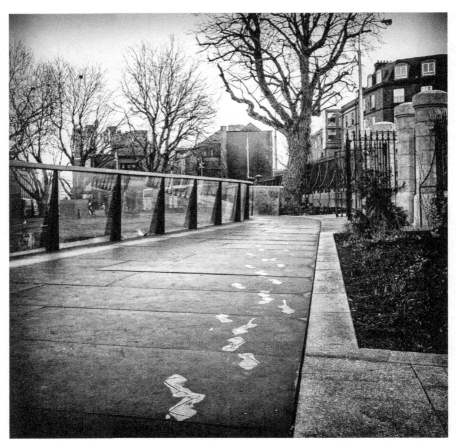

Footsteps in the morning light

*This early morning shot **Footsteps in the morning light** on the boardwalk in front of Christchurch Cathedral is all about light and shadows, with the footprints clearly highlighted on the wet paving by the low-rising sun. Walking into the city the light from the sun was in my face, highlighting the footprints as I reached the walkway. Getting lower down accentuated the converging lines of the walkway and rails, and some contrast enhancement in post really brought out the footprints from the darker felting on the path.*

Shooting during or after rain is a fabulous time for street photographers. Urban environments almost always look better when wet, with deeper contrast, and opportunities for lovely reflections from puddles of water and also just wet surfaces. As long as you are prepared for being out in rainy weather, it's well worth the effort. Just make sure that you have a lens hood to protect your lens from stray water droplets and a cloth to wipe the camera down if it's not fully weather sealed.

Another thing I often keep in my rain jacket pocket is a plastic bag. They scrunch up to almost nothing in your pocket, but can be very useful when kneeling down on wet paving or ground which is often what you need to do to make maximum use of puddles or wet ground for reflection shots. Even the smallest puddle can appear like a huge reflecting body of water if you place your camera right down at the water's edge on the ground or just a hair off it, and images taken like this can be very dramatic, offering a view of the scene not normally experienced. The shot *Christchurch reflection* in the section *"Reflections"* is one such shot.

14. Secret shooting

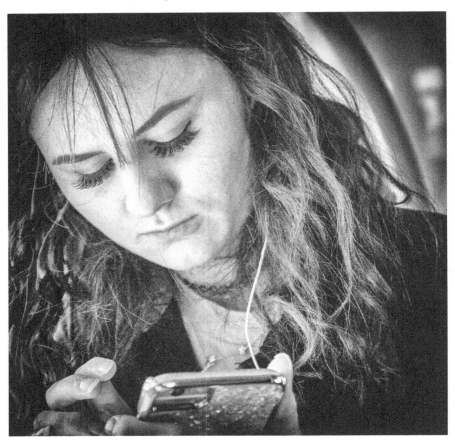

Absorbed

*This photo **Absorbed** of the young lady immersed in her phone was shot on the 25A bus heading home from town one evening. I was on the back seat, and she was in the seat immediately in front of me, not more than three or four feet away. And yet, due to the X100s' completely silent leaf shutter, I was able to snap a set of images without her becoming aware that she was the subject of my interest.*

Some people who I've discussed this with have expressed opinions that this is wrong – that I shouldn't be capturing images covertly. I completely see why they say that, but people out in public are fair game for street photographers (at least in Ireland), and most shots taken in this genre involve some degree of unawareness on the part of the subject, so I feel reasonably comfortable in continuing to shoot like this on occasion. If she had looked up and expressed concern about my actions, I would have talked with her, showed her my images on the phone, and if necessary, deleted them had she requested this. No point in causing offence for the sake of a street photo, but otherwise? No problem – no foul, as far as I'm concerned.

"The camera is an excuse to be someplace you otherwise don't belong. It gives me both a point of connection and a point of separation."

Susan Meiselas

In dozens of shooting expeditions I've never once had anyone who did react and engage with me when they were aware I'd taken their photo ask me to delete the shot. In fact, in all cases to date, as I've explained what I am doing in shooting street, they've been interested and positive. I also always carry some business cards with my photography details, and in these cases will give them a card, and suggest that if they drop me an email, I'll be glad to send them a copy of the shot – which I always follow up on if such emails are sent.

Un seen below is another of my on the bus shots – again my subject is engaged in her phone, as so many people seem to be wherever they are these days. Conversation on the bus is now very rare… Now children, or people in distressed emotional states – these I would not try to capture like this.

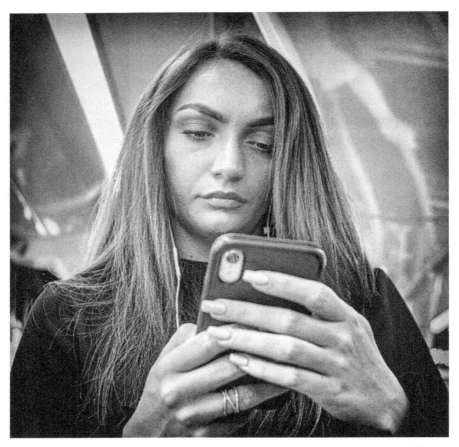

Un seen

Un seen is another of these covert on-the-bus shots. Amazing how wrapped up she is in her phone. My camera is almost directly in her line of sight, and no more than a couple of feet away from her, yet she is oblivious to my taking the shot. The silent electronic shutter and flip screen make this kind of shot possible. Note the very narrow depth of field: her face is in focus but her hands and also the background are not, so she is separated from both these areas of the shot and stands out clearly. The triangle formed by lines of her arms, shoulders and hair move the eye up to her face and her right eye, which is the focus point of the image.

15. Portraits

"It's one thing to make a picture of what a person looks like, it's another thing to make a portrait of who they are."

Paul Caponigro

You see all sorts out on the street. This one of the endlessly fascinating aspects of this type of photography. No matter where you shoot, even if it's a well-worn haunt, there are new faces, new stories, different interactions, weather, light. And capturing the people you encounter up close and personal is a challenge, a privilege and can produce some very satisfying and memorable shots.

The Portraits gallery on the website is at :
https://www.houghtonphoto.com/streets-of-dublin/#portraits

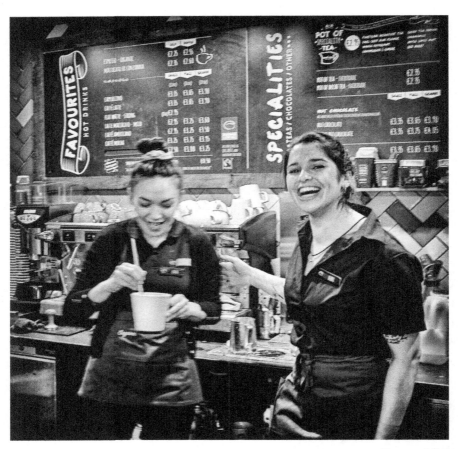

Eva and Bibi

Eva and Bibi *were happy! As I waited for my hot chocolate after a bitterly cold hour's shooting out on O'Connell Street, I just had to snap them as they kidded around behind the counter. I asked them if I could, and the first couple of shots I took were all stiff and posed, then I made as if to take my camera down from my face and they both just cracked up, which is when I took this frame. The candid, or at least off-moment shot is often the best one, so I try to shoot a few when I have a chance at a portrait, and it's so often the last ones that are the keepers. I sent them the shot and they were very happy with it, and so was I. Technically, not perfect, but that's almost the point. The movement, for me at least, adds to the life of the photo – a joyful moment in time captured forever.*

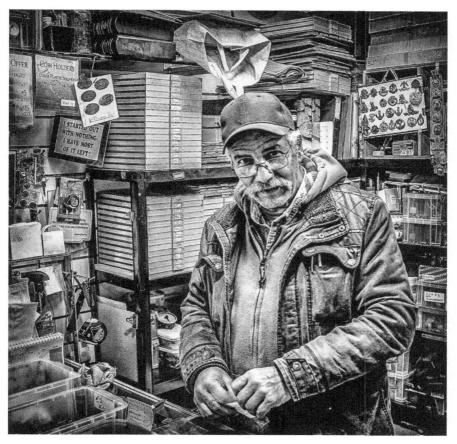

Market trader

There's a wonderful little arcade in central Dublin called George's Street Arcade, a fabulous mishmash of shops, stalls and colourful emporia. As I wandered happily through there, this chap caught my eye, and I asked him if I could take his picture. He seemed confused as to why I would want to, but happily if a little quizzically posed for me. Grizzly guys often make good portraits, and he's no exception, especially with the weathered jacket and fleece underneath adding texture to the shot. This is one image where the busy background, full of all the knick-knacks he sells, adds to the shot. He's in his space, small and full as it is, and I was really happy with this rendition of him in his element.

Aphrodite

Aphrodite was one of my first attempts at engaging someone on the street as I wandered along Henry Street. This beautiful young woman was just standing by a shop window, and I very nearly chickened out and walked past her. But taking a breath, I stopped, asked if she would mind if I took her portrait, and to my surprise, she was happy to pose for a moment. Not surprisingly, this has garnered more likes than most of my other shots on Instagram. However, it will forever be the time I mustered up the courage to face the fear and ask a complete stranger to pose for me that is the key memory out of this image.

As a follow-up, when I had posted the image onto Instagram, I'd mentioned in the text I wrote alongside the image that if anyone knew her, I'd like to send her a copy, and a few days later, she contacted me to ask for a copy. Turns out Aphrodite is actually Madalina, a TV presenter and model from Romania, in Dublin for a weekend when I ran into her. Small world – and amazing that an image posted could be so quickly linked with its subject when we had no other previous contact or knowledge of each other.

Cool couple

Cool couple. Having your camera with you and ready to shoot is so important in street photography. I finished up my day doing some coaching in Dublin recently, and put my coat on, as always, hanging my camera around my neck as I headed out. A colleague asked why I was putting the camera on as I was just going for the bus, and this shows the different mindset you should cultivate when shooting street especially: always have your camera ready! I walked down Winetavern Street under the beautiful archway connecting Christchurch Cathedral with the Synod Hall (now Dublinia), and halfway down the hill to the Quays I came upon this lovely couple. I just had to stop and ask them if I could take their portraits, which they were happy to let me do.

Wonderful shots are lost forever if you aren't ready to capture them – always have your camera out, check your settings and focus point, and be ready for the unexpected.

And this shot leads me into a theme I only realised I was developing as I've scanned my growing collection of street shots: guys with beards…

15.1. Guys with beards

I'm still pretty new to street photography, and the challenge of stopping complete strangers and asking to take their portrait is one I'm continuing to work on: developing my confidence. As I'm bearded too, although not as impressively as the guys below, beards always catch my eye, and the post-processing technique I employ for my urban street images lends itself to the detail found in hair and beards.

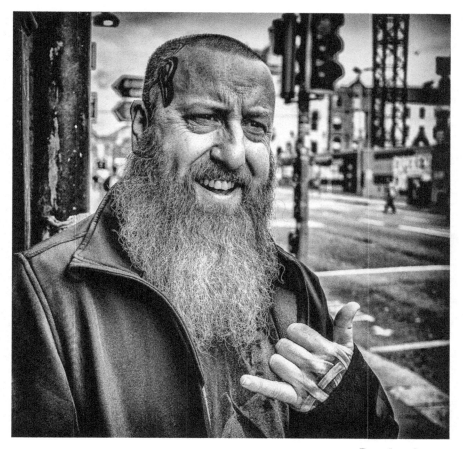

Beard and tattoos

It's also a lot easier (for me, anyway) to stop and ask a guy. I always explain that I'm shooting a portrait series of guys with beards, and so far, no one has turned me down. I still feel more uncomfortable stopping a woman to ask her. I don't want to come over as some pervy middle-aged nut job. And anyway, women don't tend to have beards.

As you can see from this section, there are some real hirsute characters wandering the streets of Dublin.

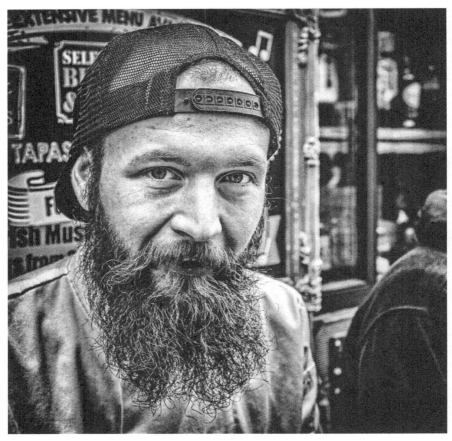

Cool chef

Cool chef *It's interesting to see how each person presents themselves to have their portrait taken. I don't generally direct them, as I find it fascinating to see how they arrange themselves. Some give the camera a direct stare, others look off to the side. I always give them my card and offer to send them a copy of the shot, and more recently I've also taken to asking them their name, so I can title their image more specifically. This also helps further establish a link as we chat and I introduce myself.*

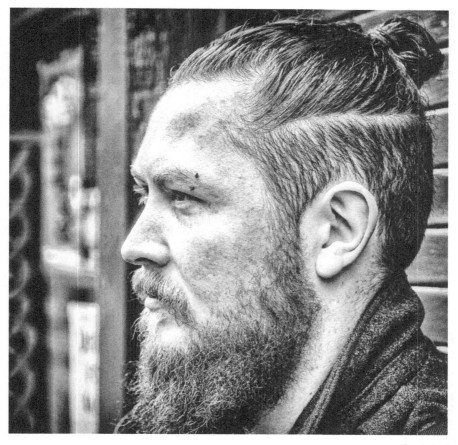

Cool dude

Cool dude As I mentioned with the previous image, some people give you eye contact but others, like this guy, want to look off into the distance. The only direction I gave him was to step a pace away from the wall so I could get some depth of field to separate him from the background. The cloudy day gave a lovely soft light and diffuse shadows in this shot.

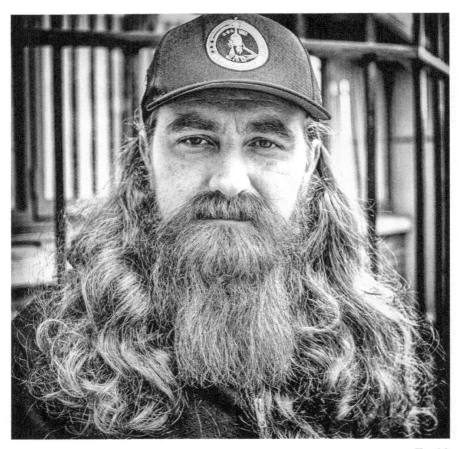

Freddie

Freddie *was a real find, standing opposite Christchurch near Jury's Hotel one day. I had a good chat with him, and found out that he's been in Viking and Game of Thrones as an extra. He certainly fits the parts in both of those shows!*

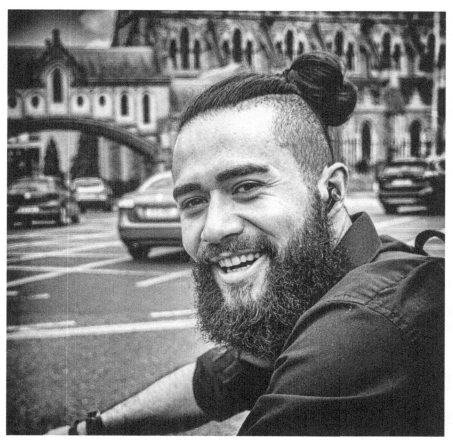

Happy cyclist

Happy cyclist *This guy drew up alongside me on his bike as I was crossing the junction in front of the Christchurch Bridge you can see in the background, and was very happy to pose for a second as I took a couple of shots. Shooting this kind of off-the-cuff portrait sure gets you into the mode of being able to quickly change your settings – as I wander the streets I'm often at f/8 to get a good working depth of field, but for portraits I try to get some separation and throw the background out of focus using f/1.8 or f/2. The tactile controls really add to my experience taking these images. Sometimes I almost feel like a "proper" photographer when I bag a shot like this one!*

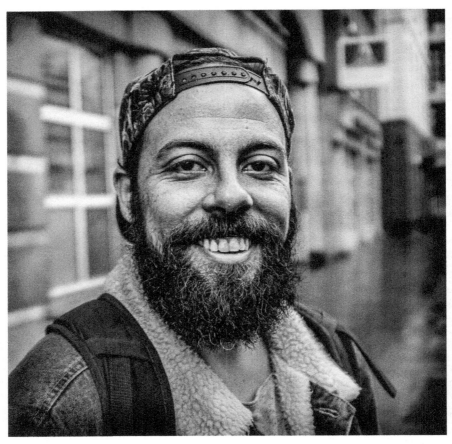

Smiling in the rain

Smiling in the rain – another happy face, no matter that it was a wet day!

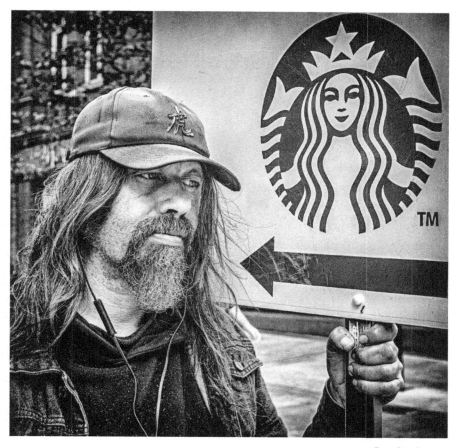

Starbucks man

Starbucks man *was very happy for me to take his photo, and I loved the way his distant, melancholy gaze and the arrow reflect each other, with the calm face of the twin-tailed Siren in the logo gazing down on him. Did you know that the logo is based on a 16th century Nordic woodcut?*

16. Some Irish street photographers

Ireland is home to some prodigious photographic talent, and in my wanderings I've bumped into a few shooting street who I'd like to share with you.

16.1. Jim Leonard

Jim and I did a course at UCD together a few years back and discovered our mutual love of photography during the coffee breaks. As a digital shooter, I'm always impressed by those like Jim who shoot film, and it's great seeing his work from around Dublin and further afield shot on a variety of old but still very serviceable cameras of all formats. Jim's work is always thoughtful, and makes me appreciate anew the varied vision we all have when behind the lens. See Jim's work on his Facebook page at :

www.facebook.com/jimleonardphotography

16.2. Peter O'Doherty

I've followed Peter's work for several years now, and his street work has inspired me to get out and shoot in Dublin. His images can be seen at his Facebook page at www.facebook.com/pg/PeterODohertyPhotos.

16.3. Shay Hunston

Shay and I have discussed photography for years now, and I've always been impressed at Shay's ability to capture amazing images on the street. From his fashion shots of models at some of the world's key events in London and Milan, to his stunning collection of mono portraits around the Wild Atlantic Way – Ireland's West coast, and more recently some fabulous landscape work, Shay's work is of a standard I aspire to reach some day. His website is at www.shayhunston.com.

17. Other street photographers to learn from

The world is full of photographers, and street photography is a vibrant genre with many well-known and emerging talents. The following are some who I've become aware of in my own explorations, so this is by no means a comprehensive list, but it's a great place to start if any of these names are new to you. Enjoy!

17.1. Henri Cartier-Bresson

If there's one person who qualifies as the father of street photography, I guess HCB would be that person. One of the founders of Magnum Photos, he wielded his beloved 35mm Leica and defined photography for generations afterwards, his style epitomised in the now classic "decisive moment" phrase talked about earlier on.

17.2. Vivian Maier

Take a long, luxurious look through http://www.vivianmaier.com/ to see some of the seminal street and other photography images of the past 100 years. Vivian passed away in 2009, leaving behind a legacy of over 40 years of wonderful imagery, now carefully curated and presented through the website above.

17.3. Dorothea Lange

Her iconic photo *Migrant mother*, which came to symbolize America's Great Depression will forever be one of the most powerful images ever taken, showing Frances Owens Thompson and her two children in a moving and unforgettable portrait of adversity. It's also a great example of photography that made a difference. In this case resulting in 20,000 lbs of food being sent to the camp where Owens Thompson and many others were starving and homeless.

17.4. Bruce Gilden

Known to many as a New York-based street photographer who employs a distinct style of getting up close and personal with many of his subjects, often using flash. Bruce's work is provocative and not to everyone's taste, but well worth studying and reflecting on. He is also a master at presenting collections of linked images, which is a skill worth developing as you build your portfolio of work. Website https://www.brucegilden.com/ .

17.5. Valerie Jardin

A star in the current street photography firmament, Valerie is producing inspirational work, and is now a regular voice on many podcasts as well as publishing beautiful books on her photography. Her website is at http://valeriejardinphotography.com/ .

17.6. Garry Winogrand

Another influential artist in this genre, Garry passed away in 1984. A good place to start looking at his prolific portfolio is at his section on the ICP website at **www.icp.org/browse/archive/constituents/garry-winogrand** .

17.7. André Kertész

Photographing in the early 1900s, André Kertész is regarded as one of the greats in street photography. A quick Google Images search for his name shows an impressive array of timeless images, which I've enjoyed perusing and learning from.

17.8. Steve McCurry

There are probably few people in the world aware of photography who don't *know The Afghan Girl – the* iconic, mesmerizing image of Sharbat Gula, captured in 1984 in a refugee camp in Pakistan and featured on the cover of *National Geographic* magazine in June 1985. It was the first time she had ever been photographed, and her piercing gaze has become one of the best-known photographs of all time. Steve McCurry is without doubt one of the world's top photographers, and should be required reading for anyone seeking to learn more about street and portrait photography. His book *The Unguarded Moment h*as been a seminal influence on my own learning about this craft, and I would highly recommend it to any lover of amazing and memorable images.

17.9. Olaf Sztaba

I discovered Olaf on YouTube, where he has a fascinating series of short videos showing him taking street photos in different cities around the world. They give a really good sense of how he visually processes scenes – very differently from how I do, and very focused on the interplay of light, form and shadow. Well worth a look. Search for olafphoto on YouTube.

18. In conclusion

If you've made it this far, thanks for staying with me, and I hope you've enjoyed this journey through my thoughts on street photography. Do have a look at the website at **https://www.houghtonphoto.com/streets-of-dublin** to see the latest additions to the collection, and to find out about other ways the images are being used and shared.

18.1. Buying any of my images

If you would like to purchase any of the images in The Streets of Dublin collection, or indeed any of my other images, please do contact me at joe@houghtonphoto.com so we can work out how best to address your requirements. I'm also on Getty Images where much of my colour work is available for purchase at www.gettyimages.ie/photos/joe-houghton.

18.2. Photo walks

I've been a photography trainer for some 15 years now, and learning by doing is so relevant for photography. So if you're in Dublin, and would like to spend a few hours shooting with me, please drop me an email (joe@houghtonphoto.com) and we can set up a session. I'd love to have the chance to show you around, and see what Dublin could show us together.

18.3. Buy someone a session with me

I offer gift certificates so you can buy a friend or loved one a two hour session with me (or yourself!), which we then organise a time/date around. We can supply a nice PDF for printing out for any occasion - just let me know when you book the session at :

http://www.houghtonphoto.com/gift-certificates .

18.4. Post processing tuition

I'm also an Adobe Certified Expert in Lightroom, and have used Lightroom, Photoshop and Nik Silver Efex for many years to tweak my images, and more recently Capture 1. If a session working through any of these packages would help, I'd be very happy to help, either in person or via a remote session. Technology is amazing these days: I regularly do software tutorials with people halfway around the world using free remote connection software to link the two computers, so we can collaborate and talk at the same time. If you are interested, drop me an email and we'll get a session set up!

18.5. Photographic mentoring

Something I do with one or two people each year is extended photographic mentoring, where we work together over a period of months to up-skill you in whatever areas of photography you want to explore and develop. Drop me an email to discuss, or check out my webpage at http://www.houghtonphoto.com/1-1 to book a set of mentoring sessions.

Joe Houghton

Dublin, Ireland, September 2019

joe@houghtonphoto.com

End

Absorbed - 1/2000 sec at f / 2.8 - Fujifilm
X100S - 23 mm - ISO 4000

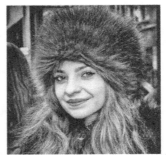

Aphrodite - 1/500 sec at f / 4.0 - Fujifilm X100S
- 23 mm - ISO 5000

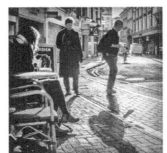

Attention caught - 1/180 sec at f / 8.0 - Fujifilm
X100S - 23 mm - ISO 800

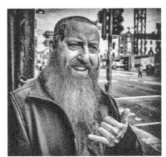

Beard & tattoos - 1/900 sec at f / 4.0 - Fujifilm
X100S - 23 mm - ISO 400

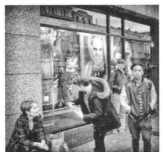

Catching up - 1/125 sec at f / 16 - Fujifilm
X100S - 23 mm - ISO 6400

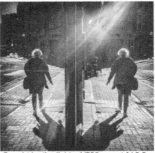

Caught by the light - 1/500 sec at f / 8.0 -
Fujifilm X100S - 23 mm - ISO 800

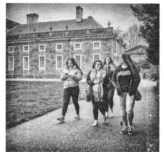

Chat at Castletown House - 1/450 sec at f / 2.0
- Fujifilm X100S - 23 mm - ISO 800

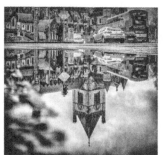

Christchurch reflection... - 1/850 sec at f / 2.8 -
Fujifilm X100S - 23 mm - ISO 250

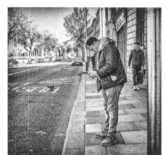

Concentration - 1/2000 sec at f / 2.8 - Fujifilm
X100S - 23 mm - ISO 800

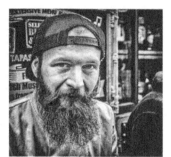

Cool chef - 1/280 sec at f / 4.0 - Fujifilm X100S
- 23 mm - ISO 400

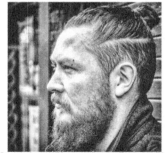

Cool dude - 1/170 sec at f / 1.0 - Fujifilm X-T2 -
85 mm - ISO 400

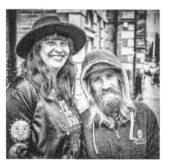

Cool couple - 1/1000 sec at f / 2.0 - Fujifilm
X100S - 23 mm - ISO 400

Distortion - 1/1800 sec at f / 1.0 - Fujifilm X-T2
- 35 mm - ISO 320

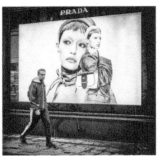

Dreams and reality - 1/60 sec at f / 2.8 -
Fujifilm X100S - 23 mm - ISO 1000

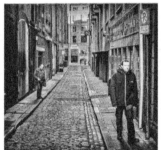

Dublin laneway - 1/30 sec at f / 4.0 - Fujifilm
X100S - 23 mm - ISO 800

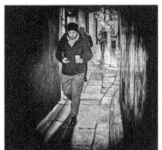

Engrossed - 1/75 sec at f / 2.8 - Fujifilm X100S
- 23 mm - ISO 800

Eva and Bibi - 1/30 sec at f / 2.0 - Fujifilm
X100S - 23 mm - ISO 320

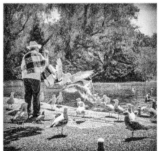

Feed the birds... - 1/550 sec at f / 1.0 - Fujifilm
X-T2 - 35 mm - ISO 320

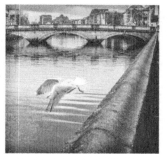

Fishing on the Quays - 1/500 sec at f / 5.6 -
Fujifilm X100S - 23 mm - ISO 250

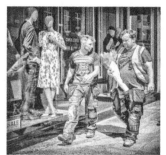

Flowers tonight - 1/800 sec at f / 1.0 - Fujifilm
X-T2 - 35 mm - ISO 320

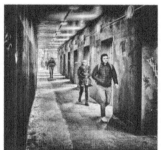

Following - 1/110 sec at f / 2.8 - Fujifilm X100S
- 23 mm - ISO 800

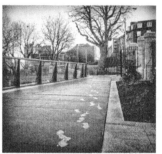

Footsteps in the morning light... - 1/170 sec at
f / 8.0 - Fujifilm X100S - 23 mm - ISO 800

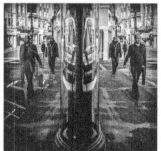

Fractured reality - 1/250 sec at f / 2.8 - Fujifilm
X100S - 23 mm - ISO 800

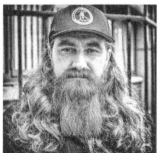

Freddie - 1/200 sec at f / 1.0 - Fujifilm X-T2 -
35 mm - ISO 320

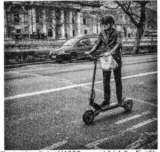

Free wheelin' - 1/1000 sec at f / 4.0 - Fujifilm
X100S - 23 mm - ISO 250

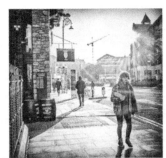

Girl contre jour - 1/1000 sec at f / 2.0 - Fujifilm
X100S - 23 mm - ISO 800

Happy cyclist - 1/950 sec at f / 1.0 - Fujifilm X-
T2 - 75 mm - ISO 400

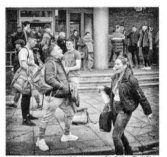

Happy days - 1/100 sec at f / 5.6 - Fujifilm
X100S - 23 mm - ISO 640

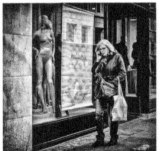

Hello? - 1/125 sec at f / 4.0 - Nikon NIKON
D810 - 42 mm - ISO 64

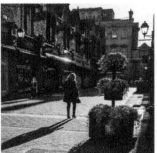

Into the light - 1/850 sec at f / 4.0 - Fujifilm
X100S - 23 mm - ISO 800

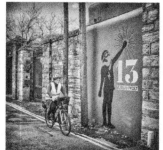

Lad Lane, Dublin - 1/900 sec at f / 2.0 - Fujifilm
X100S - 23 mm - ISO 800

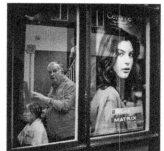

Looking ... - 1/70 sec at f / 4.0 - Fujifilm X100S
- 23 mm - ISO 800

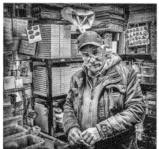

Market trader - 1/120 sec at f / 2.0 - Fujifilm
X100S - 23 mm - ISO 800

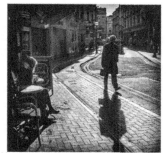

Morning routine - 1/550 sec at f / 8.0 - Fujifilm
X100S - 23 mm - ISO 800

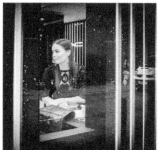

Observed... - 1/60 sec at f / 2.8 - Fujifilm
X100S - 23 mm - ISO 2000

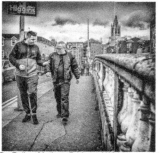

On Father Mathew Bridge - 1/1000 sec at f /
2.0 - Fujifilm X100S - 23 mm - ISO 800

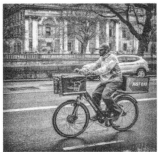

On the way... - 1/500 sec at f / 4.0 - Fujifilm
X100S - 23 mm - ISO 250

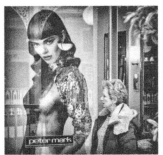

Overlooked - 1/250 sec at f / 4.0 - Nikon
NIKON D810 - 70 mm - ISO 640

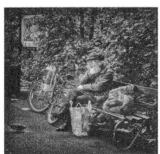

Quiet spot for a nap... - 1/60 sec at f / 5.6 -
Fujifilm X100S - 23 mm - ISO 2500

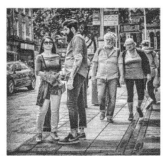

Passing glance - 1/3200 sec at f / 1.0 - Fujifilm
X-T2 - 35 mm - ISO 320

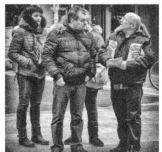

Really? - 1/200 sec at f / 2.8 - Nikon NIKON
D810 - 70 mm - ISO 64

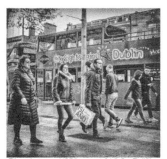

Riverdance - 1/250 sec at f / 2.8 - Fujifilm
X100S - 23 mm - ISO 320

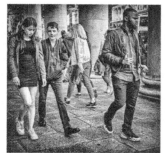

Sad lass - 1/500 sec at f / 1.0 - Fujifilm X-T2 -
35 mm - ISO 320

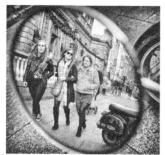

Saturday outing - 1/500 sec at f / 4.0 - Fujifilm
X100S - 23 mm - ISO 2000

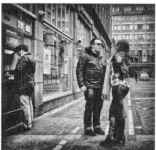

Shooting the breeze - 1/250 sec at f / 2.8 -
Nikon NIKON D810 - 24 mm - ISO 64

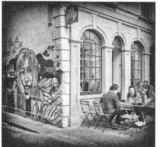

Smile - 1/120 sec at f / 8.0 - Fujifilm X100S - 23
mm - ISO 800

Smiling in the rain - 1/1000 sec at f / 2.0 -
Fujifilm X100S - 23 mm - ISO 800

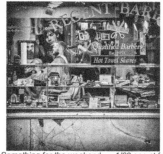

Something for the weekend... - 1/60 sec at f /
2.0 - Fujifilm X100S - 23 mm - ISO 200

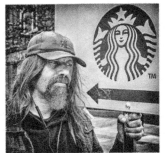

Starbucks man - 1/450 sec at f / 1.0 - Fujifilm
X-T2 - 75 mm - ISO 400

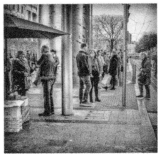

Stories at the Spire - 1/125 sec at f / 11 -
Fujifilm X100S - 23 mm - ISO 800

Stretch kiss - 1/180 sec at f / 1.0 - Fujifilm X-T2
- 35 mm - ISO 400

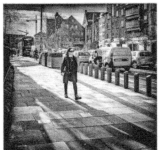

Strider - 1/2000 sec at f / 4.0 - Fujifilm X100S -
23 mm - ISO 800

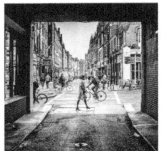

Style on Exchequer Street - 1/110 sec at f / 2.8
- Fujifilm X100S - 23 mm - ISO 800

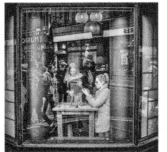

Taking a break... - 1/125 sec at f / 4.0 - Fujifilm
X100S - 23 mm - ISO 1600

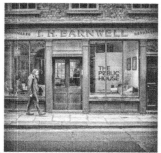

T. H. Barnwell, bootmaker - 1/250 sec at f / 4.5 - Fujifilm X100S - 23 mm - ISO 400

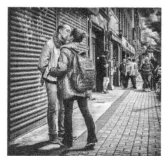

The Kiss - 1/1000 sec at f / 4.0 - Fujifilm X100S - 23 mm - ISO 200

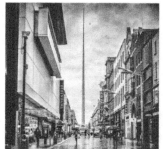

The Spire from Henry Street - 1/1800 sec at f / 1.0 - Fujifilm X-T2 - 85 mm - ISO 400

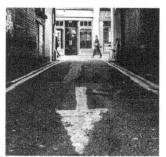

This way - 1/60 sec at f / 8.0 - Fujifilm X100S - 23 mm - ISO 3200

Un seen - 1/40 sec at f / 1.0 - Fujifilm X-T2 - 35 mm - ISO 400

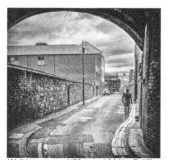

Walking away - 1/60 sec at f / 11 - Fujifilm X100S - 23 mm - ISO 800

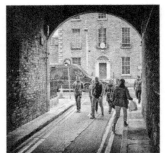

Walking through - 1/125 sec at f / 4.0 - Fujifilm
X100S - 23 mm - ISO 800

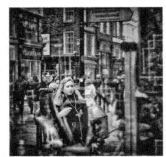

Window shopping - 1/80 sec at f / 4.5 - Nikon
NIKON D810 - 70 mm - ISO 64

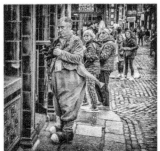

Working the street... - 1/150 sec at f / 2.8 -
Fujifilm X100S - 23 mm - ISO 800

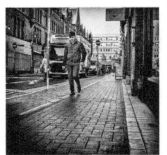

You lookin at me? - 1/170 sec at f / 8.0 -
Fujifilm X100S - 23 mm - ISO 800